# For All to See

## THE LITTLE BIGHORN BATTLE
## IN PLAINS INDIAN ART

*Hidden Springs of Custeriana - XIII*

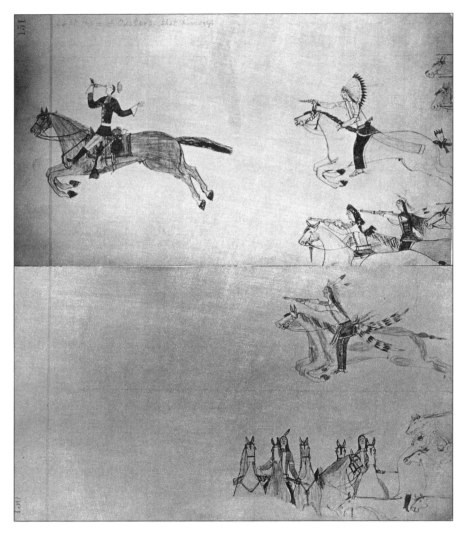

A tradition among the Sioux tells of a single soldier on a fast horse who raced away from the battlefield near the end of the Custer battle. In this drawing by Amos Bad Heart Bull, a trooper races away from the warriors behind him; his pistol is drawn, and he has just shot himself in the head. (See pages 72-76.)

From Blish, *A Pictographic History of the Oglala Sioux*, Pl. 184. Reproduced from Blish by permission of the University of Nebraska Press. Copyright 1967 by the University of Nebraska Press. Copyright renewed 1995 by the University of Nebraska Press.

# For All to See

## The Little Bighorn Battle
## in Plains Indian Art

by
Sandra L. Brizée-Bowen

*The Arthur H. Clark Company, Spokane, Washington*          *2003*

Copyright 2003 by
SANDRA BRIZÉE-BOWEN

_____

_____

LIBRARY OF CONGRESS CARD CATALOG NUMBER 2002154336
ISBN 0-87062-308-7

Library of Congress Cataloging-in-Publication Data

Brizée-Bowen, Sandra L., 1947-
  The Little Bighorn Battle in Plains Indian art / by Sandra L.
Brizée-Bowen.
    p.  cm. — (Hidden Springs of Custeriana; 13)
Includes bibliographical references and index.
   ISBN 0-87062-308-7 (alk. paper)
  1. Little Bighorn, Battle of the, Mont., 1876—Pictoral works. 2.
Indian art—Great Plains. 3. Little Bighorn, Battle of the, Mont.,
1876—Historiography. I. Title. II. Series.
  E83.876.B857 2003
  758'.997382—cd21
                                                2002154336

To my husband,
DAVE BOWEN,
and to my parents
MARJORIE AND ROBERT BRIZÉE

# Contents

# Illustrations

**For All To See**

# Preface

Much of the mystery and controversy surrounding the battle of the Little Bighorn has as its foundation the fact that there were no survivors—no white survivors, that is—of what has become known in popular culture as Custer's Last Stand. It is precisely that "no survivor" aspect of the battle that has given birth to literally thousands of pages of speculation on the way the battle was fought.

There were, however, hundreds of *Indian* survivors, some of whom preserved their recollections of the battle in pictographic drawings, a medium that records both individual and group history. This study illustrates several examples of Plains Indian pictographic works concerning the battle of the Little Bighorn. Most of these drawings are little-known, little-used, ethnohistorical primary source materials concerning an event which may well be the most controversial occurrence in the history of the American frontier.

This study discusses sixty-one Sioux, Cheyenne, and Crow pictographic drawings of the battle. Some of these drawings, representing the work of thirteen or more different artists, have been published previously in various battle histories; others, in museum collections, have been studied and published as examples of Plains Indian art. But never before have all these drawings been published together in a single interpretive work. And never before have all these drawings

been described and compared and matched detail by detail to the recorded oral testimony of Indian and white participants and witnesses. The drawings examined here are graphic illustrations of the battle and have no counterpart in the mass of white testimony and speculation concerning the battle. The drawings in this study are a "new" source of information that is neither theoretical nor particularly speculative.

These drawings unquestionably add to the body of knowledge concerning the battle of the Little Bighorn in that they (1) describe and graphically illustrate specific scenarios about which only the barest details have been known; (2) reveal a Plains Indian perspective on a major historical event; and (3) exemplify a native medium for recording and preserving history.

# Introduction

A charger, he is coming.
I made him come.
When he came, I wiped him out.
He did not like my ways; that is why.

*Standing Bear's favorite kill talk song about
the battle of the Little Bighorn*[1]

On June 25, 1876, Lieutenant Colonel George Armstrong Custer and approximately 650 men had been marching steadily for over three days, over very hard terrain, on insufficient rations; men and horses were thoroughly exhausted. After locating the huge Indian encampment situated on the western bank of the Little Bighorn River, and, being warned that the column had probably been seen, Custer ordered Major Marcus A. Reno and three companies of the Seventh United States Cavalry to cross the river and attack the camp at its southern end. At the same time, he detailed one company to protect the huge pack train. Worried that the village might soon be in flight, Custer ordered three companies of cavalry under the command of Captain Frederick Benteen to scout the area south of the village. In sending Benteen off to the left, Custer, in compliance with Terry's orders, hoped to head off any refugees who might try to

---

[1]DeMallie, ed., *The Sixth Grandfather: Black Elk's Teachings Given to John G. Neihardt*, p. 198. (For full bibliographic information on the sources cited in the footnotes, see the Bibliography at the end of this volume.)

escape in that direction; he also might have wanted to reassure himself as to the layout of the villages to avoid being surprised by the arrival of unexpected Indians from upstream. On the Washita River in 1868, Custer had failed to scout the area around Black Kettle's camp, and was subsequently forced from the field by the sudden arrival of dozens of warriors from nearby but out-of-sight villages strung for miles along the river.

At the Little Bighorn, the splitting of Custer's command into three main columns was an echo of the more involved pincer plan adopted by the three wings of the larger command under Generals Alfred Terry and George Crook, and Colonel John Gibbon—three strong, fairly independent commands expecting to rendezvous almost simultaneously within attacking, or at least supporting, distance of an enemy whose exact location in a largely uncharted territory was guessed at but unknown, and whose numbers and disposition had yet to be determined. Terry, expecting to reach the vicinity after Gibbon who had a shorter distance to travel, had expected that Gibbon would gather all possible information as to the whereabouts of the Sioux and Cheyenne camps. Their camps *had* been located by Gibbon's Lt. Bradley and his Crow scouts, but Terry was never given this information.[2] The plans later formulated by Terry, and then Custer, were based on defective knowledge since details of the movements and size of the camps found by Bradley were never shared with the two men.[3]

---

[2] Gray, *Custer's Last Campaign: Mitch Boyer and the Little Bighorn Reconstructed*, p. 164.

[3] Ibid., p. 176.

The village, thought to have been one of the greatest gatherings of Plains Indians in the history of the American frontier, was composed of thousands of Sioux, Cheyenne, and Arapaho. Some were single, unattached warriors and young men drawn to the camps by the reputations of the fighting men there. Others had just left the agencies for the summer hunts. All these had come together under the nominal leadership of the Hunkpapa Sioux headman Sitting Bull, the "old man chief" and a respected elder who stubbornly hung onto the old way of life. He had recently experienced a powerful vision which foretold of soldiers falling, headfirst, into the camps—a reassuring sign that any soldiers who dared to attack the camps would all be killed. Then, Custer and his command appeared on the scene, unaware that just over a week earlier the Sioux had met General Crook and his command on the Rosebud. The ensuing battle seems to have been a draw, but Crook and his command withdrew to resupply, leaving the Sioux and Cheyenne feeling victorious and doubly confident of their powers.

While Reno's forces forded the Little Bighorn and attacked the southern end of the village, Custer and five companies moved downstream to attack, or to at least present the threat of attack on, the opposite end of the camp. Owing to great numbers of Indians and a determined resistance, Reno's group was soon forced to retreat, at great cost, to the bluffs across the river from the camp. The warriors, freed from the pressure briefly supplied by Reno, moved to meet the new threat downstream. An hour or so later, Custer and his immediate command had been annihilated.

Reno arrived back on the bluffs as Benteen's column

rejoined the command. Benteen had earlier ignored Custer's messages to hurry back to the main column, and had not sent a single message reporting his position. Upon meeting Reno's survivors, Benteen had joined them.[4]

The soldiers watched as the Indians quickly withdrew down the valley, leaving the men of the combined commands momentarily alone. Reno and Benteen fortified their position as well as they could during the lull in the fighting. After extra ammunition from the pack train had been rushed forward and distributed among the soldiers, a loose group of officers and men, unorganized and without orders, set off northward following Custer's trail, and moving toward the sound of firing. Several reports of distinct volleys of firing from the direction Custer had gone[5] had moved some to wonder why no one was going to Custer's aid.

When the group reached a high point now known as Weir's Point, a huge cloud of dust partially obscured the view. Crowds of mounted Indians rode in and out of the dust, seemingly firing at the ground. It was generally believed then that Custer had been driven from the field and would return with the other columns already moving toward the area. But Custer and his entire column had been defeated. What the group on Weir's Point was watching were the *coups de grace.*

By the time the tail end of Reno's command caught up with the others on Weir's Point, the earlier arrivals were being threatened by an ever-growing number of

---

[4]Ibid., p. 261.

[5]Custer's Crow scout, Curley, witnessed two volleys being fired from near Calhoun's position, 1901 interview with Walter Camp, quoted in Hammer, *Custer in '76*, pp. 161-65.

warriors appearing in their front. The groups turned about and returned to the first position, which they continued to fortify in anticipation of an attack. Having defeated Custer and his men, the Indians turned the full force of their attention, as well as their newly-acquired carbines, on these other soldiers.

Reno and Benteen ordered the men to the perimeters of the shallow depression they had chosen to defend. There was little cover for the soldiers; they hurriedly threw up earthen breastworks but there were few digging implements with the command and their efforts accomplished little. Boxes of supplies from the pack train were stacked up to shelter the more exposed areas. A field hospital was established in the center of the depression, and the horses were tethered there to provide some cover for the wounded men.

The men on the bluff suffered from thirst during the long siege. Parties of volunteers made the perilous trip down the bluffs to get water. Only one soldier was killed in the attempt to reach the river.

The soldiers held the position on the bluff the rest of that day, and most of the following until the Indians withdrew. The soldiers cautiously left their positions, watching and cheering as the hostiles broke camp and moved off toward the southwest.

On June 27, outriders from Gibbon's column reached Reno's position with the astonishing news that Custer and all his men lay dead three miles away. The relief columns, commanded by General Terry and Colonel Gibbon, had arrived on schedule, finding that Custer had been drawn into a battle which had cost the lives of about 260 men.

After many separate countings of the dead and

speculative postmortems, the dead had been hastily and scantily buried. Terry's column escorted the survivors back to the Yellowstone River. There the wounded boarded a steamboat, *The Far West,* piloted by Captain Grant Marsh. The boat set navigation speed records on its downstream run to Bismarck. A few days later, during the nation's centennial celebrations, the news of Custer's defeat reached the American public. Outrage and disbelief helped fan a controversy that has continued, unnoticeably diminished, to this day.

# 1

In the words of an old military man, it is only by the comparison of the opinions of different men that the world can arrive at the truth of any subject.[1] This statement is particularly apropos of the battle of the Little Bighorn.

After the appearance of hundreds of publications on the circumstances of the battle, and especially after the passage of more than a century, it could scarcely be expected that new, untapped sources of information would be uncovered. But in 1984, an archaeological survey of part of the battlefield netted an unexpected result. For the first time, Indian survivor testimony, including many pictographic narratives of the battle of the Little Bighorn, was corroborated by scientific evidence.

Before the survey provided such a large measure of support for the Indian side of the story, many historians accorded Indian sources scant respect. Native sources which could have been pursued and examined while the participants were still alive were avoided because they were rooted in an incomprehensible cultural system, or because they were in conflict with popular and accepted notions of what did and did not happen.

After the battle, military authorities, journalists, and other interested parties approached the Indian survivors in the hopes of learning what had happened to George Custer and the men who had followed him

---

[1]Dodge, *The Plains of the Great West,* p. vii.

into battle. Scores of Indians were interviewed, but their statements were—and still are in some circles—received with a degree of skepticism not accorded to the white survivor testimony. Of the surviving soldiers with Reno and Benteen, none witnessed the Custer battle. Yet those survivors provided clearly speculative testimony and a collection of battlefield observations that has become the core of the literature written about the Custer battle.

Those who flocked to interview the Indian survivors faced tremendous language and cultural differences and a scarcity of competent, reliable interpreters. The skill and biases of the interpreters and interviewers, the types of questions asked, the manner in which the answers were phrased, and even the mood of the Indians being interviewed affected the quality of the testimony. Many Indian participants of the battle were afraid to answer questions directly or truthfully. The battle was a delicate subject; for many years the Indians believed that the endless questions were designed to identify the most prominent warriors so they could be punished. It was not until after the turn of the century that some Indians were finally convinced there would be no further retaliation for the Custer battle.

The testimony of the Indians, hundreds of whom survived the Custer battle, is obviously significant since no one else lived to tell the story of what had happened to Custer and the men under his immediate command. Flying Hawk, a Sioux participant of the battle, commented succinctly, "[No] white man knows [about the Custer battle]. None left."[2]

---

[2]McCreight, *Chief Flying Hawk's Tale: A True Story of Custer's Last Fight, as Told by Chief Flying Hawk*, p. 31; quoted in Stewart, *Custer's Luck*, p. 432.

One noted author of several books on the American West has stated, "The Sioux and Cheyenne participants, of course, left reams of testimony [on the battle of the Little Bighorn], but no one has succeeded in structuring it in time and space."[3] The same historian also wrote,

> From the confused and contradictory accounts of the Indian participants and from the placement of the bodies on the [Custer] battlefield, the movements of the contending forces can be roughly constructed. . . . [But the details of the action] must ever remain a mystery.[4]

Another author familiar to researchers of this Custer battle, has said,

> It is impossible to reconstruct the fighting action on the Custer field, for no participant with Custer survived to describe it, and accounts from Indian participants reveal little more than their attitudes and fighting tactics.[5]

Still another historian has declared—in a book of Indian survivor tales of the Custer battle—that since there were no white survivors of the battle, the details of that affair must "remain forever a mystery"![6]

The idea that certain aspects of the battle will never be known has been a widely-held viewpoint among historians. Some of this is due to unfamiliarity with native resources. Historians unfamiliar with Plains cultures have had understandable difficulties evaluating these materials. A few historians have realized that an understanding of Plains Indian culture presupposes

---

[3]Gray, *Custer's Last Campaign: Mitch Boyer and the Little Bighorn Reconstructed*, p. xi.
[4]Utley, *Custer Battlefield National Monument*, p. 31.
[5]Gray, *Custer's Last Campaign: Mitch Boyer and the Little Bighorn Reconstructed*, p. 384.
[6]Hardorff, *Lakota Recollections of the Custer Fight: New Sources of Indian-Military History*, p. 15.

the appropriate and effective use of the Indian source materials. But most authors on the battle of the Little Bighorn have evidently chosen instead to place little reliance upon native sources, possibly because of the inherent difficulties involved in placing in the proper perspective, the Indians' versions of the battle and their ways of telling it. William A. Graham, one of the most thorough Custer battle historians, acknowledged the many discrepancies, inconsistencies, and false-hoods in the white versions of the battle. But he believed these irregularities were easier to assess than those in the Indian versions because the white men at least spoke English while the Indians did not.[7]

It is an undeniable fact, whatever the explanation, that historians have tended to overlook Indian testimony on the battle of the Little Bighorn *except* where it corroborated white theory or belief. In the numerous instances in which Indian accounts contradicted popular opinions, the Indian testimony was held to be inaccurate. For example, many Indian accounts of the battle of the Little Bighorn state that Custer's column, or someone from it, rode down Medicine Tail Coulee, all the way to the river. Other native accounts say that the column started across the river and was turned back midstream by opposing fire from the opposite bank.

Soldiers examining the ford immediately after the battle found tracks made by shod horses in the coulee and at the ford; some theorized that Custer's men had reached that point while attempting to cross.[8] Dead

---

[7]Graham, *The Custer Myth, A Source Book of Custeriana*, p. 4.

[8]Miller, *Custer's Fall*, p. 127; Johnson, *The Red Record of the Sioux*, pp. 94, 99; Grinnell, *Fighting Cheyennes*, p. 357; Hammer, *Custer in '76*, pp. 86, 116; Godfrey, "Custer's Last Battle, by One of His Troop Commanders," pp. 379-80; Capt. Philo Clark and Lt. Edgerly, quoted in Graham, *The Custer Myth*, pp. 116, 221, respectively.

soldiers were reportedly found near the ford,[9] and some dead gray horses identified as belonging to E Co. were found there also.[10] It was concluded nevertheless that Custer's column had at no time approached nearer to the river than the site where Custer died.[11] Many later historians have concurred with this opinion.

There is archaeological evidence to support the Indians' assertion that, sometime after the departure of Reno and Benteen, Custer *again* divided his command, this time into two wings, and that Cos. E and F almost certainly rode far down Medicine Tail Coulee toward the river. Although the historical record on the presence of Custer's soldiers in Medicine Tail Coulee and at the ford is contradictory, the artifactual evidence clearly shows that at least part of the battalion reached the river and then turned away.[12]

Those historians who have made use of the Indian materials relating to the battle of the Little Bighorn have been able to write with a richness of detail lacking in accounts based solely upon white accounts. One such source is the book, *Cheyenne Memories*, by John Stands in Timber, Northern Cheyenne tribal historian. In his book, he told for the first time stories about the battle which few non-Indians had ever heard. The stories were well-known to the Cheyenne,

---

[9]Ryan, *Hardin Tribune,* quoted in Stewart, *Custer's Luck*, p. 443; Walker, *Campaigns of General Custer in the North-West and the Final Surrender of Sitting Bull*, p. 53; Godfrey, "Custer's Last Battle, by One of His Troop Commanders," pp. 379-80; Godfrey later reversed his previous statement and said no bodies were found near the ford. Interview with Lt. DeRudio, quoted in Hammer, *Custer in '76*, p. 86.

[10]Interview with Lt. DeRudio, quoted in Hammer, *Custer in '76*, p. 87.

[11]Godfrey, "Custer's Last Battle, by One of His Troop Commanders," p. 380; Graham, *Abstract*, p. 143. Benteen and Godfrey at first believed Custer had ridden all the way down to the river, but both later came to have a different opinion.

[12]Scott and Fox, *Archaeological Insights into the Custer Battle,* p. 13.

but the holy nature of the stories had kept them secret for many years. Stands in Timber explained how he had learned about the Custer battle: "Many different men told me about that battle. If a person kept listening he would hear a great deal. . . . Each man saw what he saw, and had his own experiences."[13] Stands in Timber also learned much about the battle from his grandmother, widow of Lame White Man, a Northern Cheyenne leader killed in the battle.

The fact that no *white man* lived to tell of the Custer battle is at the heart of a point of view which has ignored hundreds of Indian survivors and witnesses, their battle accounts, and a large number of pictographic drawings relating to the battle. This viewpoint ignores a wealth of new information and evidence corroborating Indian accounts, which was uncovered during the 1984 archaeological survey of part of the Custer battlefield. The examination of both the archaeological record and the Indian primary sources can surely reveal much that was previously unavailable to, or overlooked by, historians. At the very least, these details can provide clear, strong color to what was once just a dull gray outline of hazy shapes and foggy speculations.

I am convinced that the re-examination of all native sources including pictographic drawings relating to the battle of the Little Bighorn, and their comparison

---

[13]Stands in Timber, and Liberty, ed., *Cheyenne Memories*, p. 209. Stands in Timber's book is the primary source on the story of the Sioux and Cheyenne "suicide boys," a group of young men and boys who vowed, the day before Custer attacked, to fight to the death in the very next battle. It was the entry of the suicide boys into the battle that encouraged the rest of the warriors to close in on the last of Custer's men. All of the suicide boys died in the fight with Custer. For many years, their story was kept secret among the Sioux and Cheyenne because what the young men had done was a powerful and holy thing, and not meant for white men's ears. (Ibid., pp. 194-208.)

with both native and non-native accounts, will eventually result in a much broadened view of this event. The passage of time necessitates the use of materials which have been overlooked and under-utilized, and which were once, however mistakenly, considered marginal or negligible by some historians.

# 2

After the battle of the Little Bighorn, many warriors commemorated their participation in that event with drawings on paper, hides, muslin, and canvas. These drawings served to remind all who saw them that the owner had played an important role on a day when the Cheyenne and Sioux had seemed invincible.[1]

Knowing the warriors' propensity for battle art, some white individuals commissioned drawings of the Custer battle as a round-about way of getting at native testimony that was not otherwise forthcoming. Many of these drawings survive today as examples of primitive art in both public and private collections throughout the United States and elsewhere.

Anthropologists have long appreciated the ethnohistorical content of Plains Indian pictographic drawings; historians have been slow to appreciate that they are uncommonly revealing primary sources. The following statement by one art historian sums up a view which may be shared by other historians:

> Most of [the pictographic drawings] are symbolic and, like the many stories told by Indian participants, add little to our information about the [Little Bighorn] fight—yet sometimes they can reach through to an alien and barbaric

[1]Plains Indian pictographic battle art is functionally similar to the campaign ribbons, medals, and shoulder patches used by modern soldiers to publicize battle participation, group membership, honors, and skills.

point of view and help to interpret the Sioux and Cheyenne way of looking at their world.[2]

This opinion may arise from the fact that most of these drawings are unfamiliar to historians, and that they have been treated as ethnographic artifacts, laid out in dark museum drawers, rather than subject-cataloged as ethnohistorical, primary source materials. Poor or inaccurate cataloging is often the culprit here; if the catalog doesn't lead researchers to these materials, they are effectively lost. In addition, pieces lacking context or documentation are understandably difficult to use. If publication is a measure of the awareness of such materials, few historians have known drawings such as these exist, and fewer have attempted to interpret them. According to Lloyd Kiva New, one-time Director of the American Art Institute,

> It is high time that the general public had an opportunity to see a famous (or infamous) event in history portrayed in the manner that will overcome the generally vacuous coverage given to the Native American side of stories coming out of that period of American history. . . . [The use of pictographic drawings could be] a vital force for changing commonly held historical views.[3]

There were hundreds of Indian survivors of the battle of the Little Bighorn, each with a story to tell. Some of the warriors gave their stories to non-native interviewers, while others preferred the more traditional method of rendering artistically their view of the battle and their part in a memorable day.[4] Their

---

[2]Russell, *Custer's Last,* p. 24.
[3]Tillett, *Wind on the Buffalo Grass: The Indians' Own Account of the Battle of the Little Big Horn River,* p. ix.
[4]Dippie, *Custer's Last Stand: The Anatomy of an American Myth,* pp. 36-37.

drawings are graphic illustrations of the battle and have no counterparts in the entire body of white testimony and speculation concerning the battle of the Little Bighorn.

Although many historians have utilized native testimony on the battle, few have incorporated the evidence from pictographic drawings into their work. It is hard for me to believe that this material is completely unknown to researchers, and difficult to understand why it would be rejected by so many writers. In Robert Utley's foreword to *Custer's Last Campaign*, by John S. Gray, Utley stated,

> Indian testimony is difficult to use. It is personal, episodic, and maddeningly detached from time and space, or sequence and topography. It also suffers from a language barrier often aggravated by incompetent interpreters, from the cultural gulf between questioner and respondent, and from assumptions of the interviewer not always in accord with reality.[5]

Since the type of Indian testimony was not specified, I have assumed Utley intended his statement to apply to all types of native sources. Plains Indian testimony is indeed personal and episodic; so is much of the white testimony on this event. But I will show that, at least in the case of some of the pictographic drawings included in this study, native sources are not all "detached from time and space, or sequence and topography."

By way of another example, look at this statement by Fox, whose own archaeological work on the battlefield yielded so much new data:

---

[5]Gray, *Custer's Last Campaign: Mitch Boyer and the Little Bighorn Reconstructed*, p. x.

> [A]rchaeology led to insights into the effect of proximity and firepower as instruments of shock in the Custer battle. How could this be known otherwise? Indian testimonies do not tell of it, nor do they furnish clues from which it might be reasoned.[6]

Many of Amos Bad Heart Bull's and Red Horse's drawings of battle scenes show, in unmistakable clarity, just exactly what effect Indian "proximity and firepower" had on Custer's soldiers. The shock, the panic, the demoralization is there for all to see. Fox did not cite the use of any pictographic resources in his bibliography.

The Plains Indians were literate in a pictographic sense.[7] There was no system of writing as we know it today, but pictographic information was readily used, conveyed, and understood by the Plains peoples. After the Custer battle, several Arikara scouts appeared at the expedition's base camp on the Yellowstone. They drew pictures of the battle on a piece of canvas, but no one there could understand what the pictures meant.[8]

When the military was on the trail of the Indians who had participated in the Custer battle, Captain Charles King reported finding Indian "hieroglyphics" on cottonwood trees on the Tongue River. King saw numerous hunting and war scenes,[9] but was unable to explain their meanings.

In 1876, Captain Richard H. Pratt, in charge of Cheyenne prisoners at Fort Marion, Florida, told of inmates there who received a picture-letter with drawings telling them of the Little Bighorn battle. He said,

---

[6]Fox, *Archaeology, History, and Custer's Last Battle*, p. 331.

[7]Petersen, *Plains Indian Art from Fort Marion*, p. 31. Petersen's book set the standards by which other books on Plains pictographic art are written.

[8]Connell, *Son of the Morning Star*, p. 104.

[9]King, *Campaigning with Crook*, pp. 78-79.

"The Cheyennes have kept up a constant interchange of information in their rude picture way."[10]

There are literally hundreds of extant Plains Indian ledger drawings, hide paintings, and other pictographic works of art on fabric and paper. Pictographic art also appears on clothing, robes, shields, and tipi covers and liners. Most of these were originally collected as souvenirs and examples of primitive art, rather than as historical primary source materials. The majority of such pieces either have no documentation at all, or the information on the artist or the event depicted is lacking.

The manner of individualized Plains Indian warfare and the desire for battle honors is reflected in both the Indian battle narratives and the pictographic scenarios. An old-time Indian's account of any battle invariably took the form of an autobiography.[11] Generally, the main theme of such narratives is the movements of one man in relation to his comrades. The drawings might show a deed by a lone warrior, or a bird's-eye view of a combined action by a large group of warriors. The apparent absence of recognizable locations and verifiable times did not bother the Indians, who would have known where and when such events had occurred anyway; and, in any event, the drawings were not meant to stand alone as silent documentaries. The warrior-artists periodically displayed and discussed their drawings and re-enacted the events depicted in kill-talks, a culturally accepted medium of self-glorification as well as oral history.[12] The drawings

---

[10]Petersen, *Plains Indian Art from Fort Marion*, p. 31.

[11]Vestal, *Sitting Bull, Champion of the Sioux*, p. 179.

[12]Hardorff, *Lakota Recollections of the Custer Fight: New Sources of Indian-Military History*, p. 18.

served as both visual aids and memorials to a man's war career. In the words of an old-time Sioux elder, "The picture is the rope that ties memory solidly to the stake of truth."[13]

A warrior's standing depended largely upon his war record, which he carefully preserved for all to see as part of his culture's rich oral and pictographic tradition.[14] Plains Indian pictographic drawings were customarily made by the man whose deeds were being commemorated,[15] and were intended more for the sake of personal glory than tribal history. The war honors system of the Plains Indians required documentation and verification. No man could claim any honor without physical evidence or corroborative testimony from his peers. Drawings of battle exploits had to be accurate for they were open to challenge by anyone.[16] A reasonable amount of accuracy was important. Exaggeration was accepted, but fiction was not. No honorable warrior would deliberately falsify his account of an action.

Most of the white soldiers in the drawings in this study are nearly identical and anonymous adversaries. The anonymity of the rendering is indicative of the fact that, to the Indians, so many of Custer's soldiers fought and died in a completely undistinguished way. Some soldiers, however, are drawn in great detail. Different uniform styles, hats, rank insignia, weapons, and hair or beards highlight figures which have become individuals. The drawings indicate that certain officers

---

[13]Wheeler, *The Scouts,* p. 141.

[14]O'Brien, *Plains Indian Autobiographies,* p. 6.

[15]Blish, *A Pictographic History of the Oglala Sioux,* p. 21.

[16]Wheeler, *The Scouts,* p. 141.

and enlisted men distinguished themselves on the battlefield either by their bravery or the lack thereof, and thus immortalized themselves in the minds of their Indian counterparts.

In most pictographic drawings, the warriors are depicted as distinct individuals, identifiable by dress, medicine charms, face paint, shields, and pony markings. These identification details should not be taken literally, for a warrior did not always have time to properly assemble all his favorite accouterments before he went into battle. If a man customarily wore or carried a certain item, he would be pictured with that item as a means of identifying him to those who well knew the paraphernalia associated with particular individuals. In modern American culture, we need only to see Uncle Sam's red, white, and blue outfit to immediately identify the character; his clothing is far more significant than his face, and he is instantly recognizable in almost any context. So were Plains people able to recognize portraits of contemporaries by emblematic articles of dress and weaponry.

Much Plains Indian pictographic battle art is as documentational in nature as are, for example, Mathew Brady photographs of the Civil War. But Plains pictographic drawings can be as biased as photographs in that they show misleadingly small views of a larger event; they may impart an unreal significance to relatively ordinary events; or the images may be full of anonymous people with few clues as to location or time. But in the absence of written histories, these drawings must be accepted as some of the only old-time tribal commentaries we are likely to get.

To one not familiar with Plains Indian pictographic art, the drawing style seems childish, primitive, and untutored. In reality, the majority of Plains Indian art closely conforms to a set of fairly rigid criteria.[17] Plains Indian artists generally conformed to traditional standards of perspective, motif, and spatial arrangement. Most details were drawn flat and two dimensional, as the eye sees them. An example of this is the portrayal of only the torso of a human body because the legs are obscured by the banks of a river or gully; or when an incomplete figure straddles the physical edge of the drawing surface. Anyone looking at the drawing should know that whole persons and entire bodies were actually intended. The exception to "as the eye sees it" detailing is the artistic license taken with identification devices such as shields, for example, which, if shown in a realistic view from the edge, would reveal no clues as to the identity of the owner whose deeds are being commemorated.

These drawings reveal much of Plains Indian warfare and value systems. Even more significant is the depiction of the Plains Indian attitude toward war, with its emphasis on the individual rather than the group, personal daring, trophy-taking and spirit helpers. The drawings included here unquestionably evoke a very real sense of time and space, and a feeling of what it must have been like to be on the banks of the Little Bighorn River, on June 25, 1876.

Much more important is the ethnohistorical content of each drawing. The renderings convey and corroborate a body of information that has long been available

---

[17]Petersen, *Plains Indian Art from Fort Marion*, p. 18.

for all to see—but few have bothered to look. When questioned about the battle, the Indians had answered, and the white interviewers had not believed the answers given. The Indians' stories were ignored and discarded. The opinions, speculations, and misconceptions made public after the battle by the Reno and Benteen soldiers who survived the battle were given greater value. The troops who arrived too late to take part in the battle but who were on the field early enough to observe physical evidence left accounts which were sufficient to color a bevy of battle myths.

The Indian testimony has gained additional corroboration from the evidence recovered on the battlefield itself during the archaeological survey prompted by the accidental grassfire of 1984. Until the artifacts recovered in that survey were plotted on a huge computer map, there were no real descriptions or proof of any one battle scenario[18]—except in the Indian accounts and the drawings. According to Douglas Scott who oversaw the archaeological operation for the National Park Service, the data resulting from the survey supports "much in the Indian accounts of the battle and contradicts none of them."[19] Hard evidence and scientific methods have helped validate Indian testimony, including the pictographic drawings made to commemorate the deeds of men who took part in a great battle.

---

[18]Robotham, "Is This the Bullet That Killed Custer?", p. 121.
[19]Scott and Connor, "Post-Mortem at the Little Bighorn," p. 54.

# 3

Most of the drawings presented here are documented as to artist and date of execution. In some cases, the subject matter of the drawings is well documented; in others, I have placed the drawings in my own synthetic context which is based upon my comparison of each drawing with textual references.

There are most probably dozens of extant drawings depicting the battle of the Little Bighorn, but without *some* documentation or visual clue, they remain lost to use for the time being.

This chapter is divided into sections dealing with specific Sioux, Cheyenne, and Crow artists and selected drawings attributed to them. Many of these drawings have been published previously, but in most cases, the interpretations accompanying the drawings in those sources do not include explanations of the numerous pictographic details of each, the implication of such details, or possible linkages with historical texts. This study examines and explains each drawing within the contextual framework of the battle of the Little Bighorn and the subsequent testimony relating to it. Permission to publish some of the drawings was not obtained and the images are therefore omitted. In the absence of illustrations, those drawings have been described here as fully as possible; the footnotes provide information about previously published illustrations,

and current whereabouts, when known. The reader is encouraged to find those sources and examine the drawings using this text as an aid to interpretation.

Most of the pictographic drawings examined here are the products of participants in, or eyewitnesses to, the battle. The remaining drawings were made by artists who heard the details of the action, time and time again, from actual participants.

Within the section allotted to each artist, the drawings are in my chronological order. But because some individual artists depicted scenes from widely dispersed parts of the battlefield, I have not been able to maintain a strict chronology overall.

Because many of the drawings in this study concern somewhat different views of the same events, some of my descriptions are repetitive. I have tried to hold this to a minimum by providing appropriate testimony for each event from various participants whose statements, though worded differently, concern the same or a similar event.

The text accompanying the illustrations of the pictographs are in my own words since few of the artists included descriptions with their work. My descriptions of the events in the drawings have been written in the present tense; references from contemporaneous testimony are in the past tense.

## White Swan

White Swan was one of the Crow scouts enlisted for the 1876 campaign, and brother of Curley, another scout. When Custer left the base camp on the Yellowstone, General Terry sent several Crow scouts and their interpreter Mitch Boyer with his column. This was a region with which the Crows were familiar; Custer's Arikara scouts, although loyal men and fierce fighters, did not know this part of the country.

When Custer ordered Reno and three companies to charge the village, he sent the Arikara scouts in advance to run off the Indian horse herds grazing on the benchlands to the west and above the villages. Through a misunderstanding, White Swan and another Crow scout, Half Yellow Face, ended up accompanying Reno's column down into the valley.[1] The rest of the Crow scouts and Mitch Boyer rode off with Custer.

A handful of drawings attributed to White Swan exist in various collections. I could not obtain permission to publish the first one discussed here. This drawing is a montage of scenes which occurred in Reno's fight in the valley where White Swan was wounded.[2] The painted tipis of the Sioux and Cheyenne camp are visible in the upper left corner of the drawing. At the left bottom edge, White Swan, wearing a white man's hat, uses a telescope to scan the valley of the Little Bighorn below and to the west. He has left his cavalry-saddled horse tied to a tree. White Swan had

---

[1]Interview with Scott, quoted in Graham, *The Custer Myth*, pp. 12-18; and Gray, *Custer's Last Campaign*, p. 278.

[2]Muslin painting attributed to White Swan, from the collections of the Paul Dyck Foundation, Rimrock, Arizona.

been one of the scouts sent ahead by Custer to the Crows Nest, a high place near the divide between the Rosebud and Little Bighorn. From that point, the Crows said, any village in the valley of the Little Bighorn would be visible.

Along the right edge of the drawing, White Swan is seen riding a different horse than the one seen tied up at the Crows Nest. White Swan fights with an un-mounted soldier. On Reno's orders, White Swan was sent to bring back a deserter. The private, shown in the drawing with a single chevron on his sleeves, re-sisted, giving White Swan a blow to the head that left him deaf.[3] Reno had seen the trooper slipping away while the column was in the timber. When Reno sent White Swan after the man, White Swan thought Reno wanted the man killed. Since Reno had no Crow interpreter, it is unknown how these orders were con-veyed. It is not surprising that White Swan misunder-stood Reno's intentions. White Swan followed the soldier, and when he resisted, White Swan killed him. Reno never mentioned White Swan's actions.[4]

In the left center of the drawing, White Swan's cavalry horse is wounded in two places. White Swan is prepar-ing to scalp an enemy warrior who has probably just fired the shots wounding White Swan's horse. The up-right guidon behind White Swan may be an indication that this action occurred near the valley skirmish line, where the company flags were planted in the ground.

Immediately below the scene with White Swan and the soldier is a Sioux warrior with a red cape, beaded or painted leggings, his hair tied up with two feathers thrust through the knot. White Swan's horse is par-

---

[3]Wheeler, *The Scouts*, p. 147.
[4]Miller, *Custer's Fall*, pp. 100-01.

tially superimposed on the Sioux warrior's horse, possibly a sign that White Swan ran this warrior down, horse and all.

In the lower right corner of the drawing, White Swan, wearing a red cape (taken from the Sioux warrior?), counts coup on an armed Sioux warrior wearing painted or beaded leggings and a feathered headdress. Above this scene, White Swan pursues a figure identified as Sitting Bull's nephew, One Bull, who is riding double behind a wounded friend.[5] One Bull led the counter-attack against Reno's valley assault.[6]

Across the top of the drawing, White Swan is pursued by an enemy warrior; then he counts coup on a distinctively dressed and accoutered Sioux or Cheyenne warrior, and then counts coup again on a warrior who is drawing an arrow from his quiver.

In the upper center of the drawing, the horse of the other Crow scout has been wounded, and its rider shoots a Sioux warrior who is carrying a saber and who falls from his horse. Again, the upright guidon here may indicate the skirmish line position.

At the bottom left of the drawing, White Swan, bleeding heavily from at least two leg wounds and possibly another in one arm, shoots a Sioux warrior off his horse. At the lower left corner, an officer leads a cavalry horse that drags White Swan's sunshaded-travois from the battlefield. [See p. 159, Kicking Bear drawing of a dead Crow scout with an umbrella. Kicking Bear may have seen the badly-wounded White Swan being carried, shaded, from the battlefield and later assumed the scout had been killed.]

The mounted officer with the raised saber at the left

---

[5]Wheeler, *The Scouts*, p. 147.    [6]Miller, *Custer's Fall*, p. x.

edge of the drawing may be Reno ordering the bugler, also pictured, to sound the call for the charge or withdrawal.

In Fig. 1,[7] White Swan is shown dismounted and looking at the camps in the valley of the Little Bighorn. He is looking through a telescope next to a tree against which he has leaned his carbine. The scene is very similar to the Crows Nest vignette in the previous drawing.

On the way down the western side of the divide, the scouts had climbed to this point, leaving their horses at the bottom of the rocky knob, in an attempt to verify if the Sioux were indeed camped on the floor of the valley. The Crow scouts had said they could see the huge pony herds, but officers who climbed up to see what the scouts could see, weren't so sure, in spite of the telescopic view. It was at this point that Custer was given another in a series of warnings that an alarmingly large number of Indians was almost certainly camped just a short distance away.

In Fig. 2, White Swan is shown stripped down for battle, and preparing to loose an arrow at a Sioux or Cheyenne warrior carrying a feathered lance and a painted shield with an eagle feather streamer. The enemy warrior wears painted or beaded leggings, beaded moccasins, a bone breastplate, and his hair is knotted above his forehead, with two eagle feathers thrust through the knot. The figure is similar to the one with the painted shield in the first-mentioned White Swan drawing, but there, White Swan is not armed with a bow and a quiver full of arrows.

---

[7]Figs. 1 and 2, drawings on paper attributed to White Swan, from the collections of the Ernest Thompson Seton Memorial Library and Museum, The Philmont Scout Ranch, Cimarron, New Mexico.

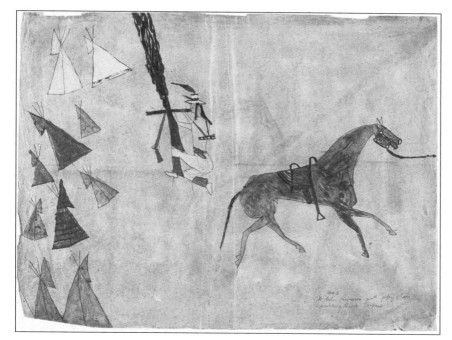

Figure 1

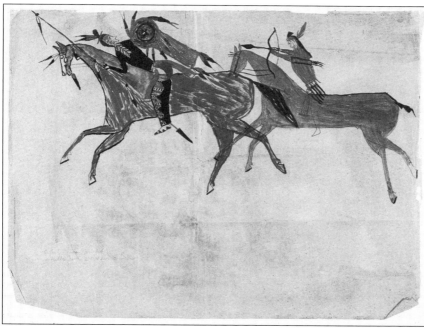

Figure 2

## Amos Bad Heart Bull

Amos Bad Heart Bull (1869-1913), an Oglala Sioux from the Pine Ridge Agency, inherited the position of band historian from his father. Amos Bad Heart Bull obtained much of his information on the battle of the Little Bighorn from Bad Heart Bull the Elder, a participant in some of the events in his son's drawings. Some information was obtained as well from his uncles He Dog and Short Bull. He Dog was also the main informant for historians and ethnographers Helen Blish and Mari Sandoz, whose works on the Sioux and Cheyenne were also consulted for this study.

Bad Heart Bull's drawings represent a historical, tribal record. His portraits of warrior societies, the battle of the Little Bighorn, and the Ghost Dance troubles of the 1890s are quite consistent with other sources.[8] Most of Bad Heart Bull's drawings are accompanied by a short Lakota text which identifies the event or the participants, or elaborates upon cultural themes.

Upon the death of Amos Bad Heart Bull, his ledger sketchbook passed to his sister Dolly Pretty Cloud. The book was buried with her when she died in 1947. Both color and black and white photographic copies of Bad Heart Bull's drawings were made before the ledger book passed out of this world. Over four hundred of these prints appear in Blish's book, *A Pictographic History of the Oglala Sioux*.[9] Seventeen of the sixty drawings about the battle are included here.

---

[8]Blish, *A Pictographic History of the Oglala Sioux*, p. 28.

[9]Over thirty of Amos Bad Heart Bull's drawings appear in Tillett's *Wind on the Buffalo Grass*. The drawings in Tillett's book are poorly identified by artist, and one

In 1938, C. Szwedzicki of Nice, France, published twenty-two color lithographs copied from hand-colored photographs of Bad Heart Bull's drawings; the series was put out as a folio entitled, *Sioux Indian Painting.* The folio was edited by Hartley Burr Alexander, Helen Blish's academic advisor while she attended the University of Nebraska. The folio includes drawings by another Sioux artist, Kills Two, including one entitled "Custer vs. Crazy Horse."[10] Copies of this folio are rare.

Fig. 3[11] is a map of the battlefield and is highly conventionalized. The map, in which east is on the left (above) the river and west is on the right (below) the river, shows the Little Bighorn River and its belt of trees and thickets. The Indian camps are visible at the lower left, below the river. Reno's command can be seen approaching in orderly formation at right center, just below the notation "June 25 and 26, 1876." The belt of timber where Reno kept his horses while his men were dismounted on the skirmish line can be seen just below the initials "G.G.A," written near the center of the drawing and partly superimposed upon the river. The advance of Custer's column, along a ridge, seen at top center, is visible just below the boxed notation, "G.G.A. Custer."

Blish states that the map shows Reno's fortified position up on the bluffs, in the extreme upper right cor-

---

drawing is printed twice. Some of Bad Heart Bull's narrative accompanies Tillett's reproductions of these drawings. Four Bad Heart Bull drawings appear in Welch, *Killing Custer: The Battle of the Little Bighorn and the Fate of the Plains Indians.*

[10]Szwedzicki, *Sioux Indian Painting;* for a reproduction of the Kills Two drawing, see also Russell, *Custer's Last,* Pl. VII.

[11]From Blish, *A Pictographic History of the Oglala Sioux,* Pl. 129. The Bad Heat Bull plates herein (Figs. 3-19) are reproduced from Blish by permission of the University of Nebraska Press. Copyright 1967 by the University of Nebraska Press. Copyright renewed 1995 by the University of Nebraska Press.

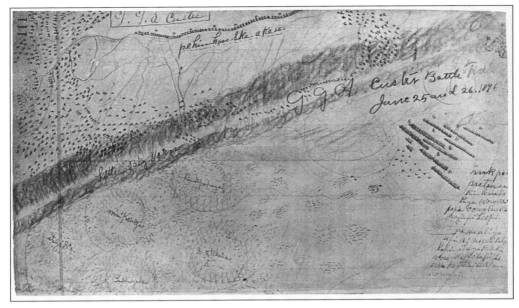

Figure 3

ner, just below the river.[12] However, Bad Heart Bull
would not have shown Reno's bluff position on the
*west* side of the river. What may be represented there
instead is the first place Reno's column was actually
seen while he was forming his column for the attack
after crossing the river.[13] Black Elk stated that some of
the first people to see Reno's column were swimming
in the river near where he crossed.[14]

Bad Heart Bull's drawing clearly shows Custer's col-
umn advancing north in clear view of the camps, on a

---

[12]Ibid., p. 215.

[13]Pictographic art frequently shows a past action in conjunction with a present one
in order to provide a setting or an explanation of how an event came to pass.

[14]DeMallie, ed., *The Sixth Grandfather: Black Elk's Teachings Given to John G. Nei-
hardt*, p. 181; Stands in Timber and Liberty, ed., *Cheyenne Memories*, p. 195.

ridge some distance back from the river. The Cheyenne leader Two Moons saw Custer's approach, and described seeing flags coming up over the hill, and then soldiers appearing.[15]

In Fig. 3, above the line representing the river, hordes of mounted Indians move to surround Custer's column. Many of the Indians are seen crossing the river directly opposite the camp that Bad Heart Bull has labelled "Hunkpapa." When first seen, Custer's column was silhouetted against the skyline of the ridge.

Later, after Reno had retreated from the valley, Crazy Horse, Gall, Crow King, and a group of Cheyenne warriors crossed the river, and, under cover of an intervening ridge, made their way into the ravines to the north and west of Custer's position.[16] Many smaller parties of warriors also crossed the river elsewhere and moved up various ravines and gullies toward Custer's column.[17]

Numerous separate groups of mounted horsemen, indicated in the drawing by clusters of dashes, are moving against Reno's column as it approaches the south end of the camp, in a skirmish line formation.[18] Reno's soldiers reported that the Indians created a huge dust cloud which obscured the warriors' maneuvers; the cloud grew as the soldiers neared the camp.[19]

In the drawing, only a few warriors oppose Reno at first, but more are on the way. A wavy line stretching from left to right, from the camp almost to Reno's left

---

[15]Utley, *Custer and the Great Controversy*, p. 111.

[16]McLaughlin, *My Friend the Indian*, p. 148.

[17]Grinnell, *Fighting Cheyennes*, p. 351; Graham, *The Custer Myth*, pp. 72, 84-85, 97.

[18]Vestal, *Sitting Bull, Champion of the Sioux*, p. 162.

[19]Miller, *Custer's Fall*, p. 86.

flank, is the ravine from which hundreds of mounted Indians suddenly appeared in Reno's front.[20] The ravine was formerly known as Box Elder Creek; its present name is Shoulder Blade Creek.[21]

Fig. 3 represents a bird's-eye montage, whose scenarios are relatively widely separated in time; these are not simultaneous events. For instance, Crazy Horse and the others with him had not yet begun to move against Custer's column while Reno was still approaching the southern end of the great camp.

Fig. 4[22] is also a map of the Little Bighorn battlefield. The scale is somewhat larger than that of Fig. 3, and the five camp circles are more clearly drawn here. This drawing is also a montage of non-simultaneous events.

As can be seen in the drawing, the bluffs rise steeply from the river. Reno's position on the bluffs is visible at the upper right corner. His position there is entirely surrounded by Indians. The row of flags in the lower right corner of the upper half of the drawing represents Reno's earlier position in the valley. Above the flags, a rough, smudgy circle indicates the timber, and Reno's position there is marked by lines of soldiers; the position is being rapidly surrounded by Indians. Reno's withdrawal from the timber was undoubtedly very timely.

Bad Heart Bull did not explain the three crosses or X's seen in the left half of the upper half of the drawing. The one farthest to the left probably marks the site of Custer's "last stand."

---

[20]Morris and Mangum, ed., "Reno's Battalion in the Battle of the Little Bighorn," *Greasy Grass,* p. 5.

[21]Hardorff, *Lakota Recollections of the Custer Fight: New Sources of Indian Military History,* note p. 26.

[22]Blish, *A Pictographic History of the Oglala Sioux,* Pl. 170. Courtesy Univ. of Neb. Press. See note 11.

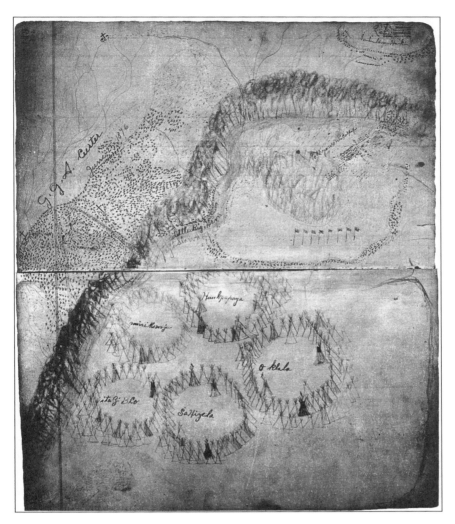

Figure 4

This version of the map gives a sense of the great numbers of Indians who eventually confronted Custer and his men. Warriors literally swarm over parts of the battlefield, overrunning cavalry positions.

**49**

In Fig. 5[23], Reno's advance upon the Indian camp from the left, or east, is observed by two Sioux, identified by Bad Heart Bull as Kicking Bear and Hard to Hit. One of the warriors is carrying a lance-headed bow. They are firing at the troops from behind brush or trees; the first time most of the Indians in the camps became aware of Reno's column was as it emerged from the trees along the river, although it seems that some were aware of it earlier. Standing Bear, a Minneconjou Sioux, reported on Reno's advance, and then on Custer's:

> On the other side of the Hunkpapas toward the south, I saw soldiers on horseback spreading out as they came down a slope to the river.... I could see that the Hunkpapas were running, and when I looked over onto the hills toward the south and east I saw other soldiers coming there on horseback.[24]

Bad Heart Bull, Amos's father, although not pictured here, may have witnessed Reno's approach along with Kicking Bear and Hard to Hit.[25]

After crossing the river, Reno's column had paused to reform.[26] In Fig. 5, Reno's column is advancing in good order, weapons ready, in anticipation of the attack on the south end of the camp. All of the soldiers are as yet unaware that they have been seen, and that Indians are so close.

Reno had not gone far before it was evident that there were a great many more Indians camped in the valley than had been estimated. The bluffs and the fo-

[23]Blish, *A Pictographic History of the Oglala Sioux*, Pl. 131. Courtesy Univ. of Neb. Press. See note 11.

[24]Neihardt, *Black Elk Speaks, Being the Life Story of a Holy Man of the Oglala Sioux*, p. 116.                                      [25]Ibid., p. 217.

[26]Gray, *Custer's Last Campaign*, p. 267.

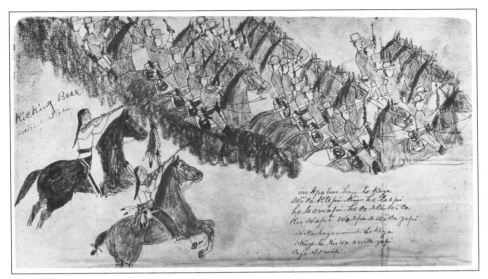

Figure 5

liage of cottonwoods had hidden the camps from view. After moving a short distance from the river, Reno sent a messenger to Custer with the news that the enemy was moving up the valley in force. At first Reno had fully intended to charge through the village as ordered. But shocked at the sight of hundreds of tipis stretching downstream, he ordered his men to halt, and then formed them into a dismounted skirmish line stretching almost from the river to the hills, with the Arikara scouts on the higher end of the line, away from the river. Later, during the Court of Inquiry called mostly at Reno's request, Reno testified that he had known nothing of the topography of the battlefield, and had the command advanced another three hundred yards, it would have plunged without warning into a ravine filled with hidden warriors.

**51**

In Fig. 6,[27] three mounted Sioux charge Reno's flank in a scene which could depict either his retreat from the skirmish line near the village, or his withdrawal from the timber. One Indian is firing a revolver; one of the other two may have a Winchester carbine. The soldiers hold their single-shot carbines and six-shot Colt .45 single-action revolvers ready, but none of the soldiers returns the Indians' fire. As yet there have been few casualties among the soldiers; there is but one riderless horse. At the bottom of the drawing, three dismounted soldiers run along behind the retreating column. It appears that the soldiers at the rear of the column are the only ones who are aware that the Indians are behind them. Officers and soldiers ride together as the formal column formation begins to deteriorate. The presence of officers at the end of the column indicates an about-face movement made as part of a sudden retreat.

In this drawing, the details of the soldiers' uniforms are clearly drawn. The styles of the uniform blouses and the insignia—shoulder-boards for officers, and chevrons for the enlisted men—indicate rank. The trousers of the issue cavalry uniforms have yellow stripes down the outsides of the legs.

Many warriors rode around to Reno's rear where they were able to inflict great injury on the column.[28] The Sioux quickly flanked Reno's first position, and forced him to pull back into the timber, where he hoped he would find a better defensive position. But the Indians crept through the woods and began firing on Reno's men. Reno decided that the timber position

---

[27]Blish, *A Pictographic History of the Oglala Sioux*, Pl. 137. Courtesy Univ. of Neb. Press. See note 11.     [28]Brininstool, *A Trooper with Custer*, p. 30.

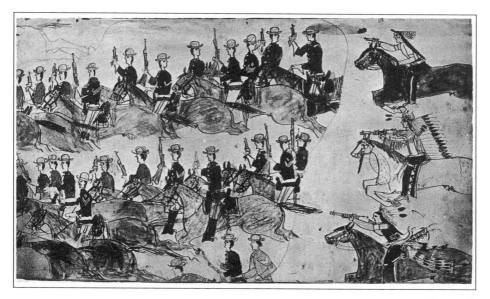

Figure 6

could not be held, and he ordered the men to retreat. When his soldiers emerged from the trees, the Indians thought the soldiers were charging them, but it soon became apparent that the soldiers were retreating. Then the Indians were upon them, riding alongside and firing at pointblank range.

When his position in the timber had become untenable, Reno had ordered his men to draw their revolvers and to follow him. Someone had shouted, "Every man for himself!" and some of the command, hearing the order, had moved out of the timber and retreated toward the river.[29] The Indians had been surprised when the soldiers had burst at a run out of the timber. They

---

[29]Morris and Mangum, ed., "Reno's Battalion in the Battle of the Little Big Horn," *Greasy Grass*, p. 5.

had expected the soldiers to make a stand there and were beginning to arrive in force. Iron Hawk, a Hunkpapa Sioux, said, "Many of the Hunkpapas were gathering in the brush and timber near the place where the soldiers had stopped and got off their horses."[30] The retreat caught the Indians by surprise, but they recovered quickly.

Reno's orders to mount and withdraw from the timber were unexpected, and went unheard by many of his men. The position seemed a fairly strong one, but at the order, some soldiers grabbed their horses from the holders and raced off, while others were left behind. The column was spread out as it emerged from the timber, and the resulting confusion gave the surrounding Indians, all opportunistic fighters accustomed to reacting quickly to such advantageous situations, a chance to cause a lot of harm to those who were left in the timber, and to those stragglers who were widely separated along the route of the retreat.

In Fig. 7[31] Reno's command is now in full retreat. A bearded officer has been shot in the back with an arrow; he is closely pursued by a Sioux warrior with a bow and wearing a long war bonnet. Other soldiers have been wounded and are being closely followed by warriors with bows and firearms. A warrior in the upper right corner of the drawing brandishes a stone-headed war club. None of the soldiers returns the Indians' fire. Three empty saddles indicate the number of casualties. Lt. McIntosh, who had a beard and was himself part Indian, was killed during Reno's retreat. He could not control his horse, and it ran away from

---

[30]Neihardt, *Black Elk Speaks*, p. 122.
[31]Blish, *A Pictographic History of the Oglala Sioux*, Pl. 135. Courtesy Univ. of Neb. Press. See note 11.

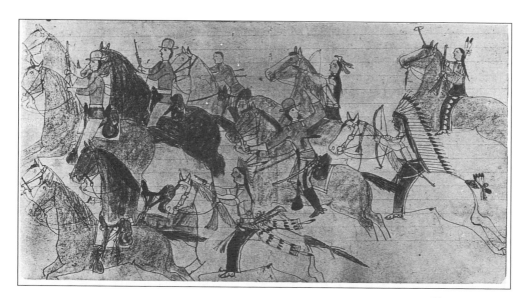

Figure 7

the rest of the column. A warrior pulled McIntosh off
his horse and killed him with a stone war club.[32]

The drawings depicting Reno's attack in and retreat
from the valley show an increasing number of warriors
riding among the soldiers. The horses are being
pushed harder and harder by their riders as the sol-
diers become more panicked and demoralized. The
soldiers are concerned only with flight, and seem to
make little effort to defend themselves.

The Indians reported that the horses of Reno's men
moved very sluggishly during the retreat, as if they
were very tired.[33] Some warriors later reported that
chasing Reno's men back across the valley to the river

---

[32]Hardorff, *Lakota Recollections*, note p. 136.
[33]Marquis, *Wooden Leg, A Warrior Who Fought Custer,* p. 221.

was as easy as killing game.[34] American Horse, a Northern Cheyenne who took part in the battle, agreed; "It was like chasing buffalo," he said.[35]

When Reno's men emerged from the timber, they attempted to return to the ford they had first used. But pressure from the Indians forced them in a more easterly direction, almost at right angles to the first trail.[36] The retreating troopers were forced to ride through the crowd of Indians to get to the river and safety.[37] Many dismounted troopers returned to the timber to hide rather than cross the river on foot in broad daylight. Eventually most found their way to Reno Hill.[38]

Fig. 8[39] shows more Indians riding unopposed into the midst of Reno's retreating soldiers. Few of the soldiers return the Indians' fire, and none bothers to aim first. Some warriors have stopped to strip a dead soldier, and two warriors have captured loose horses.

In this drawing, some soldiers have lost their hats in the rush to escape. The hatless soldier in the center of the drawing is firing into the air without taking aim. Standing Bear said of Reno's retreating soldiers:

> When we rode into [Reno's] soldiers I really felt sorry for them, they looked so frightened. They did not shoot at us. They seemed so panic-stricken that they shot up in the air. Many of them lay on the ground, with their blue eyes open, waiting to be killed.[40]

---

[34]Powell, *People of the Sacred Mountain: A History of the Northern Cheyenne Chiefs and Warrior Societies, 1830–1879, with an Epilogue, 1969–1974*, p. 970; Vestal, Sitting Bull, p. 164.

[35]Powell, *People of the Sacred Mountain*, p. 1014.

[36]Graham, *The Custer Myth*, p. 96.

[37]Sandoz, *Crazy Horse, The Strange Man of the Oglalas*, p. 326.

[38]Gray, *Custer's Last Campaign*, p. 289.

[39]Blish, *A Pictographic History of the Oglala Sioux*, Pl. 143. Courtesy Univ. of Neb. Press. See note 11.

[40]Standing Bear and Brininstool, ed., *My People the Sioux*, p. 83.

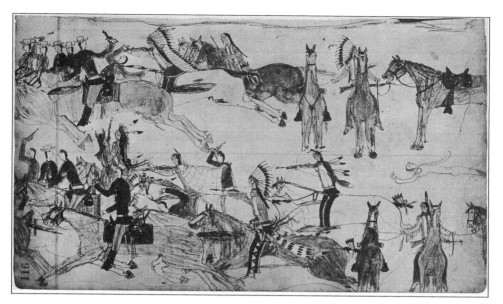

Figure 8

Standing Bear's father later said there was no honor to be had in a battle against such weak adversaries.[41] When he was interviewed, Little Knife had stated that Reno's retreating soldiers had fired wildly over their shoulders, even killing some of their own comrades. Some of the soldiers whose horses had run away met the pursuing Indians with their hands up in a futile effort to escape their fate.[42]

Fig. 9[43] includes a frontal portrait of a Sioux warrior, an uncommon feature in Plains Indian pictographic drawings. The man wears a war bonnet, a bone breastplate, and two armbands, possibly German silver. He

---

[41]Ibid.                    [42]Hardorff, *Lakota Recollections,* note p. 53.
[43]Blish, *A Pictographic History of the Oglala Sioux,* Pl. 140. Courtesy Univ. of Neb. Press. See note 11.

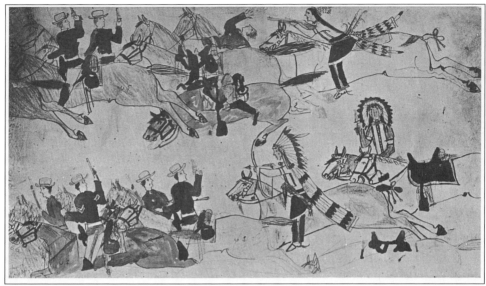

Figure 9

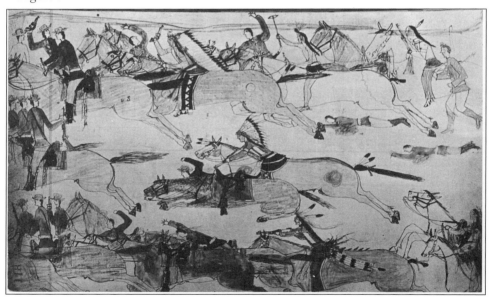

Figure 10

holds a revolver, and his face is painted with vertical stripes below the eyes. He leads a captured white cavalry horse from the field.

At the top of the drawing, a warrior fires at several soldiers who make no effort to kill him. At the bottom of the drawing, a warrior with a long war bonnet and a bow and arrow prepares to loose another arrow. In front of him, several soldiers shoot into the air. One of the troopers has an arrow in his back, and another arrow has struck a comrade's horse. Riderless horses follow along with the others, while some stumble and throw their riders.

Fig. 10[44] is a view of Reno's retreat from the valley. At the top of the drawing, a warrior raises a stone-headed war club to strike a soldier. In front of the warrior is a man with a long, horned war bonnet. In the center of this scene, a war bonnet man fires at a soldier. At the bottom, a warrior with a feathered roach on his head fires a Winchester at two troopers. Along the left edge of the drawing are soldiers who make no effort to defend either themselves or their unfortunate comrades. At the right, a dismounted soldier hurries along behind the retreating soldiers; dead soldiers are on the ground in front of him.

Fig. 11[45] depicts Reno's retreat from the valley. In the lower half of the drawing, an unmounted soldier runs after his comrades. Behind him, an officer is run down by a mounted warrior. In the lower right corner, two soldiers sit dazedly upon the ground. In the lower left corner, a warrior with a horned war bonnet shoots a soldier from his horse. In the upper half of the draw-

---

[44]Ibid., Pl. 145. Courtesy Univ. of Neb. Press. See note 11.
[45]Ibid., Pl. 151. Courtesy Univ. of Neb. Press. See note 11.

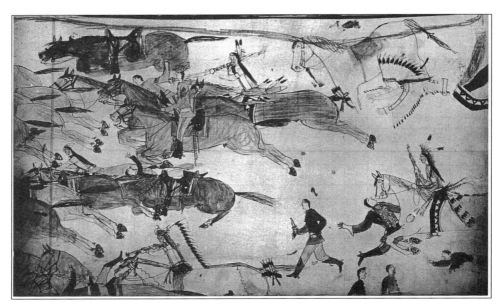

Figure 11

ing, a warrior wielding a lance-headed bow spears an enlisted man as another soldier rides by. In the upper right corner of the drawing, a war bonnet man with an ermine-tail-trimmed shirt falls to the ground.

Fig. 12[46] pictures Reno's retreat from the valley. At the top of the drawing, a warrior with a stuffed bird on his head fires his Winchester and herds a group of cavalry horses from the field. In the center, a warrior with a long war bonnet and a Winchester pursues a group of troopers. Some warriors yanked soldiers off their horses with their bare hands, not wasting arrows or bullets on them; the fallen soldiers were left behind to be trampled by the horses of more warriors closing in behind.[47]

---

[46]Ibid., Pl. 149. Courtesy Univ. of Neb. Press. See note 11.

[47]Powell, in Maurer, *Visions of the People: A Pictorial History of Plains Indian Life*, p. 96.

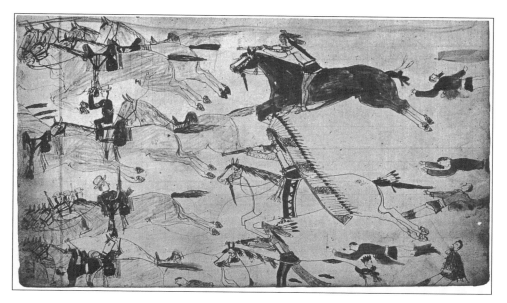

Figure 12

In the lower section of the drawing, a warrior with a feathered fur cap fires his Winchester at soldiers who are running away from him. Dead and wounded soldiers are seen along the right side of the drawing.

Fig. 13[48] is a depiction of Reno's retreat from the valley. In the upper half of the drawing, a warrior wearing a stuffed hawk on his head and carrying a lance-headed bow attacks a soldier holding a pistol. Behind the warrior, a dismounted soldier flees on foot; Red Feather, an Oglala Sioux told how he had shot horses out from under troopers during Reno's retreat.[49] The drawing shows the ease with which dismounted soldiers were killed.

---

[48]Blish, *A Pictographic History of the Oglala Sioux*, Pl. 144. Courtesy Univ. of Neb. Press. See note 11.

[49]Interview with Scott, in Hardorff, *Lakota Recollections*, p. 84.

**61**

In the lower half of the drawing, an officer with a saber looks back at the pursuing warriors following closely behind him. Another saber is on the ground at the bottom of the scene. There were no sabers—officially—at the Little Bighorn.[50] Custer had ordered the sabers boxed and left at the base camp; some soldiers may have carried the weapons into battle anyway since many of the drawings in this study show them in the hands of the cavalry.

The cavalry-issue saber, "the long knife," was not a very practical weapon on the Plains as most encounters with Indians were not fought within saber range. Sabers were frequently left behind when cavalry units went into action. Over the years of battles between the cavalry and Plains Indians, warriors had had plenty of opportunities to acquire sabers of their own to use against the "Long Knives," their term for the cavalry.

Fearing that the Indians were slowly infiltrating the position in the timber and that he would soon be cut off, Reno precipitously bolted from the timber in a mad rush for the river and the bluffs beyond.[51] Fig. 14[52] shows Reno's command being driven into the river. The Indians are firing across the river at the soldiers climbing out on the other side. At the bottom of

---

[50]Godfrey, in Graham, *The Custer Myth*, p. 346.

[51]Hammer, ed., *Custer in '76: Walter Camp's Notes on the Custer Fight*, p. 223; Brininstool, *A Trooper with Custer*, p. 64. According to Pvt. O'Neill, "The troopers rode out of the thicket by twos, those on the right being expected to deliver their fire in that direction, and those on the left to attend to that side." Also Graham, *The Custer Myth*, p. 308. But according to Graham, word was passed from man to man in the timber to get the horses. The companies formed, the troops rushed from the timber and formed in column with pistols drawn. Also Dodge, *The Plains of the Great West*, p. xxxiv. Various informants have the troopers leaving the trees helter-skelter, as individuals, and small random groups; in teams of two, and columns of fours. The only testimony that matches the drawings is the small groups and individuals versions.

[52]Blish, *A Pictographic History of the Oglala Sioux*, Pl. 158. Courtesy Univ. of Neb. Press. See note 11.

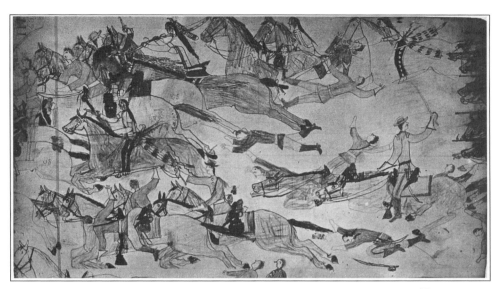

Figure 13

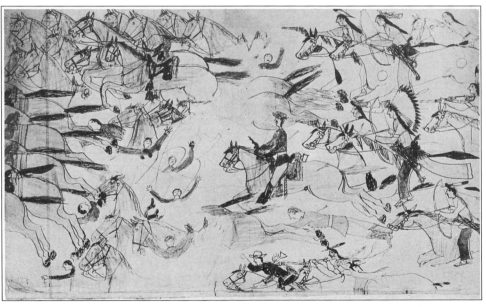

Figure 14

the drawing, a bugler is being speared by a warrior with a lance-headed bow. The Indian are relentless and overwhelming.[53]

The retreat became a wild scramble, with warriors shooting at the troopers and their horses[54] as the Indian ponies raced alongside. The soldiers fired their revolvers at the Indians,[55] often without aiming. The Indians kept crowding the soldiers.[56] Many cavalrymen had to contend with five or six mounted warriors,[57] some of whom rode with their guns resting on their pommels, firing casually into the soldier mass.[58] Black Elk said there were so many warriors that he couldn't see anything, and he didn't get a chance to shoot anyone with the revolver he had just found; there were just too many warriors ahead of him.[59]

In June of 1876, the Little Bighorn was swollen from melting snow. Reno had intended to cross the river at the same ford he had used earlier on his way toward the villages, but strong pressure from the Indians on his right when he emerged from the timber forced the column to the left and away from the original ford. As shown in this drawing, the soldiers had to ford the river where they struck it, and there was no ford in this area.[60]

---

[53]Ibid., p. 37.

[54]Connell, *Son of the Morning Star,* pp. 14, 52. The Indians fired at the soldiers' horses to bring down the troopers. Terry's command noted that the bodies of soldiers killed in Reno's retreat were almost always accompanied by a dead horse. Reno said later, "It was instant death to him who fell from his saddle. . . . Our horses were on the dead run with, in many instances, two or three men on one animal."

[55]Brininstool, *A Trooper with Custer,* p. 64.

[56]William O. Taylor to Lt. Godfrey, in Graham, *The Custer Myth,* p. 344; Graham, *Abstract,* p. 16.

[57]Dodge, *The Plains of the Great West,* p. xxxv.

[58]Graham, *Abstract,* pp. 51, 123.

[59]DeMallie, ed., *The Sixth Grandfather,* p. 183.

[60]Hofling, *Custer and the Little Big Horn: A Psychobiographical Inquiry,* p. 40; Sandoz, *The Battle of the Little Bighorn,* p. 84.

Horses plunged into the river, submerging in the deep water and swift current, losing their riders in the process. The bank became slippery as soldiers and horses scrambled desperately up the steep slope on the far side. The bank on the east side of the river was higher, and the horses had to jump to get up it.[61]

At this point, the command retained little semblance of order as officers and men were crowded together. Many soldiers were killed in this logjam. Black Elk said horses and men were all mixed up and fighting in the water, "like hail falling in the river."[62] Indians lined the bank and fired at the soldiers who were intent only upon crossing.[63] It was here near the river bank where Lt. McIntosh was pulled from his horse and killed.[64] Scout "Lonesome" Charlie Reynold's decapitated body was found in this area, with a number of empty cartridge shells nearby.[65] Most of the soldiers, however, had offered little in the way of resistance during the retreat.[66]

Crazy Horse's spotted pony is seen in the upper center of Fig. 15,[67] which takes place on the Custer battlefield. Standing in front of his pony, Crazy Horse uses a stone-headed war club to strike a soldier in buckskin clothing; the soldier's horse has fallen down. Blish identifies this soldier as Custer, but the figure could be any of the several officers reportedly wearing buckskin suits the day of the battle.[68]

---

[61]Stands in Timber and Liberty, ed., *Cheyenne Memories,* p. 200.

[62]Neihardt, *Black Elk Speaks,* pp. 113-14.

[63]Graham, *Abstract,* pp. 16-17.         [64]Graham, *The Custer Myth,* p. 281.

[65]James Taylor, in Brininstool, *A Trooper with Custer,* p. 210.

[66]Godfrey, "Custer's Last Battle," p. 371; Herendeen, *New York Herald,* 8 July 1876; Ryan, *Hardin Tribune,* in Graham, *The Custer Myth,* p. 247.

[67]Blish, *A Pictographic History of the Oglala Sioux,* Pl. 183. Courtesy Univ. of Neb. Press. See note 11.

[68]King, "Custer's Last Battle," p. 382. Custer, his brother Tom Custer, Lt. Cooke, and Lt. Keogh were dressed very nearly the same on the day of the battle.

Dead soldiers and Indians litter the battlefield. Above the figure of Crazy Horse, a warrior with a long war bonnet and a feathered lance rides down a soldier. Behind Crazy Horse's pony is a diagonal line of Indians whose upper torsos are visible. Showing the upper part of the body in such a way is a pictographic device indicating that these warriors fought from behind some form of cover. According to Flying Hawk, he and Crazy Horse rode up a ravine and got behind the soldiers on Calhoun Hill. From this cover, they and other warriors fired on these soldiers, who eventually broke and ran to join other soldiers moving toward Custer Hill.[69] Red Feather, an Oglala Lakota, said that Crazy Horse had appeared at the Custer battle when the Indians and soldiers were on opposite sides of the same ridge. Crazy Horse, blowing his eagle bone whistle, rode his horse back and forth in front of the soldiers who were firing at him, but was never hit.[70] Crazy Horse led the charge that split the soldiers there; Keogh was killed, and the gray horses of Co. E were stampeded, leaving the men afoot.[71]

Most of the warriors shown in Fig. 15 are dismounted. In fact, there are few horses belonging to either side pictured in this scene. The Indians' defensive position, the presence of Crazy Horse, and the absence of horses match descriptions of the battle at Calhoun's position, as well as at Custer's final position. Only a few Indians were on horseback in the early stages of the Calhoun action; indeed, all over the battlefield, dismounted Indians had sneaked up on cavalry positions.[72]

---

[69]McCreight, *Firewater and Forked Tongues*, p. 113.
[70]Interview with Scott, in Hardorff, *Lakota Recollections*, pp. 87-88.
[71]Hardorff, *Lakota Recollections*, note p. 88.
[72]Fox, *Archaeology, History, and Custer's Last Battle*, p. 292.

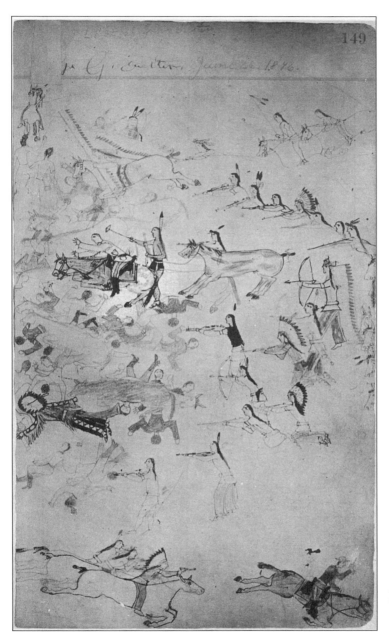

Figure 15

Exactly where did Custer and those five companies go after separating from Reno? W.A. Graham believed that Custer's actual route was irrelevant since it was perfectly obvious to everyone where he and his men had wound up.[73] But in order to make any sense of all the conflicting theories, it is necessary and useful to have some idea of Custer's movements, and to analyze a variety of scenarios.

Battle researcher Charles Kuhlman believed that Custer had divided his column again after leaving Reno, sending the gray horse troop, Co. E, down Medicine Tail Coulee while he (Custer) continued in a northerly direction toward the Calhoun positions. Kuhlman also believed that the gray horse troop, after riding down the coulee, had turned sharply to the right and rejoined Custer's column.[74] John S. Gray reached a similar conclusion, maintaining that both Cos. E *and* F had ridden down the coulee to the river, and had then immediately rejoined Custer near the southern line of the present-day monument area, not far from where Calhoun's company was deployed.[75] These two historians agreed that the men who rode down Medicine Tail Coulee were sent to decoy the Indians away from Reno, and pull them across the river toward the waiting Custer columns.

Fox believes that Custer accompanied those companies (probably E and F) which had ridden down Medicine Tail Coulee, and that when Custer had departed for the mouth of the coulee with the left wing, Cal-

---

[73]Graham, *Abstract*, p. 146.

[74]Kuhlman, *Legend Into History, The Custer Mystery*, pp. 171-72; Ege, *Settling the Dust: The Custer Battle*, p. 22.

[75]Gray, *Custer's Last Campaign*, pp. 367, 362, 358; also Curley to Russell White Bear, in Graham, *The Custer Myth*, p. 19.

houn had been left behind with the right wing to hold a position nearby and await Benteen's arrival with the pack train.[76] Fox further suggests that Custer's wing had ridden north from the coulee's mouth and had then waited at Cemetery Ridge for Benteen and the pack train to appear on the field.[77] John Stands in Timber also stated that Custer's soldiers rode all the way to the site of the present-day cemetery before turning around.[78]

Fox theorizes that Crazy Horse arrived at the Calhoun position after Custer had departed with the left wing. Once there, Crazy Horse and those with him acted as snipers to discourage any further northward movement by Calhoun's men.[79]

Why might Custer have ridden north to the area of the present-day cemetery? Part of Custer's strategy at the Little Bighorn may have been to corral the non-combatants, as at the battle of the Washita in 1868, when the capture of the women and children helped assure Custer's victory there. If Custer had believed that the women and children were fleeing north, he might have sent troops in that direction along the Little Bighorn River to cut off any chance of escape there. Fox agrees that Custer's goal in deploying men in that direction was to round up the refugees in order to force the warriors to surrender.[80] Custer may also have wanted to make a feint toward the northern end of the camps by way of supporting Reno's attack.

According to Fox, after Calhoun's men fled their

---

[76]Fox, *Archaeology, History, and Custer's Last Battle*, p. 296.
[77]Ibid., p. 305.
[78]Stands in Timber and Liberty, ed., *Cheyenne Memories*, p. 199.
[79]Fox, *Archaeology, History, and Custer's Last Battle*, p. 298.
[80]Ibid., p. 316.

initial position, Crazy Horse and his followers moved on to Keogh's sector, somewhat east/northeast of where Calhoun was positioned on the southeast end of Custer Ridge.[81]

At the bottom of Fig. 15, a soldier is racing off the page, pursued by mounted warriors. Wooden Leg, a young Cheyenne who participated in the battle, may have seen this soldier ride away. He stated that a mounted trooper suddenly appeared on the field, riding east with a band of Indians pursuing him. Wooden Leg supposed the soldier was caught and killed.[82] [See Fig. 19.]

As Blish suggests, this particular composition vividly portrays the confusion that must have reigned during the battle. The Indians drove the soldiers before them in a panic rout. Some of these soldiers threw away their carbines and pistols and raised their hands in surrender.[83] The movement of this scene is accentuated by the motionlessness of the fallen figures.[84]

The central character in Fig. 16[85] is the Oglala war leader Crazy Horse, seen here on his spotted pony, and painted with his hailstone paint.[86] Crazy Horse shoots an officer from his horse. Below the figure of Crazy Horse, another warrior spears a soldier with a lance-headed bow. One soldier, riding off the very left edge of the drawing, fires his revolver at his pursuers. The other soldiers offer no resistance. Warriors race among the soldiers, leaving a field of dead and dying men in their

---

[81]Ibid., p. 299.
[82]Marquis, *Wooden Leg,* pp. 236-37.
[83]Mallery, "Picture-Writing of the American Indians," p. 565.
[84]Blish, *A Pictographic History of the Oglala Sioux,* p. 270.
[85]Ibid., Pl. 146. Courtesy Univ. of Neb. Press. See note 11.
[86]Sandoz, *Crazy Horse,* p. 326.

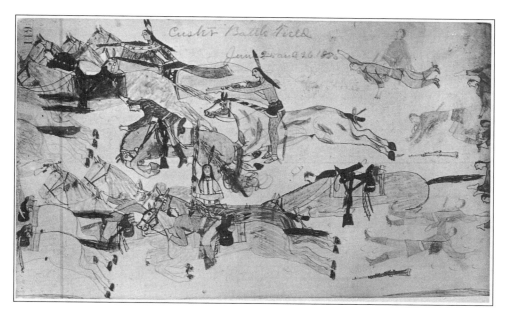

Figure 16

wake. Wounded horses stumble, throwing their riders. This scene probably took place somewhere between Calhoun's position and the site of the present-day cemetery. I have found no unequivocal documentation that places Crazy Horse anywhere else on the field.

Fig. 17[87] is a scene on the Custer battlefield. In the upper left corner of the drawing, a warrior with a bow counts coup on a soldier. In the center of the drawing, a war bonnet man with dragonfly motifs on his leggings, and holding a Winchester in his left hand uses a stone-headed war club to strike a soldier. In the lower third of the drawing, a warrior with a long war bonnet and beaded leggings fires his Winchester at a soldier

[87]Blish, *A Pictographic History of the Oglala Sioux*, Pl. 147. Courtesy Univ. of Neb. Press. See note 11.

who falls from his horse. Other warriors ride in the midst of fleeing soldiers; the ground at the right is covered with dead.

In Fig. 18,[88] many riderless horses race across a field covered with dead and dying soldiers. In the right half of the drawing, a warrior pulls a soldier from his horse. After the battle, one warrior told of riding side by side with the soldiers, wrestling with them, and trying to dismount them by playing "throwing-them-off-their-horses," a real-life game of skill much practiced by Plains Indian boys and young men.[89]

At the far right, a warrior rides down an officer. In the left half of the drawing, a warrior with a long war bonnet brandishes a captured saber, possibly taken from the dead officer with an empty scabbard seen in the lower left corner. Across the center of the drawing are two Indian horses whose rumps and necks are painted with the lightning and hail design which was believed to impart supernatural power to the animals as well as their riders. The "U.S." cavalry brands, in some ways the white man's equivalent of power-painting, are clearly visible on the soldiers' horses.

In Fig. 19,[90] a single trooper races away from the warriors behind him; his pistol is drawn, and he has just shot himself in the head. This is the soldier Wooden Leg saw. [See Fig. 15.] It is a tradition among the Sioux that near the end of the Custer battle, a single soldier on a fast horse raced away from the battlefield, in the direction of the divide. He Dog said of this soldier: "One soldier with a stocking-legged horse got away, and around the big body of Indians....

---

[88]Ibid., Pl. 148.    [89]Miller, *Custer's Fall*, p. 109.
[90]Blish, *A Pictographic History of the Oglala Sioux*, Pl. 184. Courtesy Univ. of Neb. Press. See note 11.

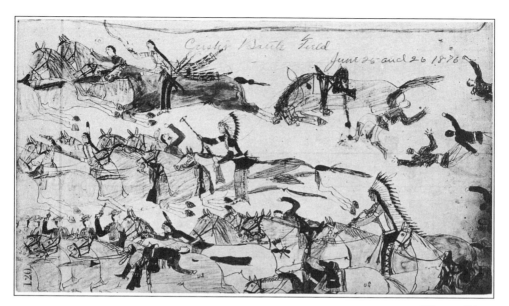

Figure 17

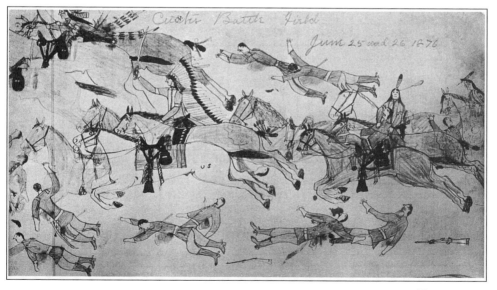

Figure 18

He had a very fast horse and was pursued. . . ."[91] The soldier rode away with a handful of warriors on his heels, but his horse was faster than the Indian ponies, and the Indians thought he would succeed in getting away. Just when it seemed that the soldier was safe, he turned to look back at his pursuers; he drew his pistol and shot himself in the head. The Indians said he could have gotten away but instead he took his own life.[92]

In her discussion of this drawing, Blish states that the soldier pictured here was the last man left alive from Custer's column,[93] but Nicholas Ruleau, a fur trader who served as a Sioux language interpreter when journalists and others came to interview warriors, had heard otherwise. In an interview in 1906, Ruleau stated that the mounted soldier who broke away from Custer's group on the ridge did so *before* the last survivors there broke for the ravine downhill.[94]

Red Feather, Oglala Sioux, remembered that the horse this soldier was riding was a sorrel;[95] the horses of Co. C were sorrels. The soldier pictured here almost certainly represents Lt. Henry Harrington of Co. C, whose body, along with others who were never found or identified, was not located.[96] The soldier depicted here, riding a horse with stocking feet, is obviously an officer, as shown by the style of his uniform blouse. According to Lt. Edward Godfrey, on the day of the battle, Lt. Harrington was wearing a blue cavalry blouse and white canvas trousers with a fringe down the outside seams of the legs.[97] In the drawing, the soldier is wearing just such a pair of trousers.

---

[91]Hardorff, *Lakota Recollections*, pp. 75-76.
[92]Blish, *A Pictographic History of the Oglala Sioux*, p. 271.  [93]Ibid.
[94]Interview with Ricker, in Hardorff, *Lakota Recollections*, p. 45.
[95]Interview with Scott, in ibid., p. 86.
[96]Graham, *The Custer Myth*, p. 300.  [97]Godfrey, in ibid., pp. 345-46.

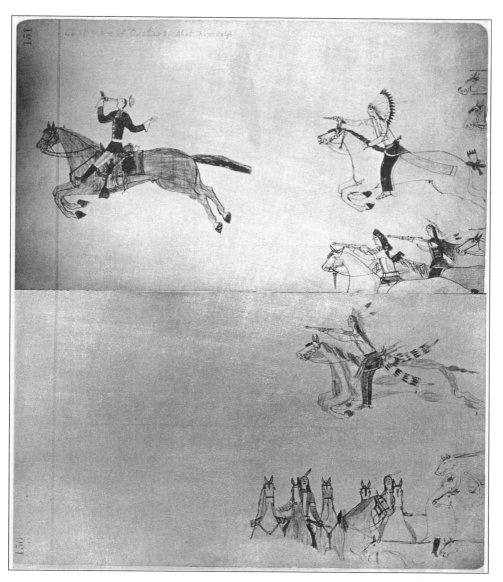

Figure 19

The warrior immediately behind the soldier in Fig. 19[98] wears a war bonnet and carries a revolver. Pictured below him are other armed warriors, one wearing a cape, and another wearing a cap with ermine tail or eagle feather streamers. Another warrior wears a feathered roach on his head.

At the bottom of the drawing, two Indians lead captured cavalry horses from the field. In the Plains Indian individualistic manner of fighting, it was not uncommon for warriors to temporarily break away from the battle in order to pursue and catch fortuitously stray horses.

In conclusion, the number and content of Bad Heart Bull's drawings convey persistent themes relative to the Reno episode. The appearance of the Indians—in terms of numbers, suddenness, and ferocity—seems to have come as a shock to the soldiers, whose maneuvers were far more defensive than aggressive. The soldiers, intent on getting away, did not retreat in a formal, orderly, military manner; they were routed, stampeded, driven off, and herded along by hordes of warriors, painstakingly depicted as particular individuals by Bad Heart Bull. The soldiers appear often as impassive participants in their own deaths. The Indians do most of the shooting and killing, while the soldiers' sole focus is escape.

The time Reno's men spent in the timber must have been of so short a duration that, to some Indian observers, no break in the dash for the river was seen to have occurred at all. The fleeing soldiers, though

---

[98]In a Bad Heart Bull drawing not included in this study [see Blish, *A Pictographic History of the Oglala Sioux*, Pl. 185], four Sioux warriors take the coat and horse of the soldier I have identified as Lt. Harrington. According to Blish, p. 272, the soldier was not scalped because he was a suicide.

armed, fired without aiming, shot into the air, and seemed to inflict only slight damage upon their pursuers. While the soldiers were strung out along the route to the river, the Indians picked off stragglers, on foot and horseback, one at a time. At the river, the Indians were free to fire at the tight bunch of men stopped at the river's edge. Bad Heart Bull has shown no soldiers here providing any protective fire cover for their comrades at the river.

While it is obvious that no observer or artist could have seen, or drawn a picture of, every single event that happened during the battle, it is clear that the overriding impression gained by Bad Heart Bull's informants was that the soldiers appeared, fought poorly, and were fairly easily killed or driven away, without much loss suffered by the Indians—all in a rather short period of time.

Somewhat the same can be said for the Custer battle episodes, but Bad Heart Bull's drawings of these events convey much less about specific locations and chronologies, as Custer's group was more dispersed spatially and temporally than Reno's. Custer's soldiers, possibly because they were surrounded and cut off from rescue, seem to have put up more of a fight than did Reno's soldiers in the valley, whose retreat gave them a way out, if a dangerous one. They took it, with no apparent thought other than to get away. Custer's group also fought, inconveniently for us, away from most handy visual reference points such as the river and stands of timber. Moreover, we have not been permitted the luxury of Custer battle survivors to fill in the missing details.

## RED HORSE

One of the most widely published and well-known Indian accounts of the battle of the Little Bighorn is that of the Minneconjou Sioux, Red Horse. His record of the event is illustrated with an accurately detailed map and forty-one pictographic drawings, commissioned and collected at the Cheyenne River Agency in South Dakota, in 1881, by Dr. Charles E. McChesney, Acting Asst. Surgeon of the United States.[99] Later, McChesney submitted the Red Horse drawings for publication, and ten of them appeared in Garrick Mallery's "Picture-writing of the American Indians" in the *Tenth Annual Report of the Bureau of American Ethnology*, printed in 1894.[100]

Red Horse's drawings consist of the following: one map; five drawings of soldiers approaching the village; five drawings of tipis; five views of charging warriors; five drawings of Indians fighting with soldiers; five views of dead cavalry horses; five drawings of Sioux warrior casualties; five views of dead and mutilated soldiers; and six drawings of Indians leading away captured cavalry horses.[101]

Dr. McChesney apparently objected to the then-popular term, "Custer's Massacre." When he forwarded the "foolishly styled" drawings to Washington, he wrote,

> If the intended surprise, with the object of killing as many
> Indians as possible, had been successful instead of being a

---

[99]Utley, *Custer and the Great Controversy*, p. 104.

[100]The Red Horse drawings appear as Pls. XXXIX through XLVIII, between pp. 563-566 in Mallery, "Picture-Writing of the American Indians."

[101]One from each category of the Red Horse drawings, except dead horses, is pictured in Maurer, *Visions of the People*. Red Horse included five drawings of tipis at the Little Bighorn; I have wondered if each sheet was meant to represent a different camp circle.

disastrous defeat, any surviving Indians might with some propriety have spoken of "Custer's massacre" [of Indians].[102]

Red Horse, a Sioux leader prominent in the battle, produced a narrative along with his drawings[103] and map of the Custer fight. Because the drawings are so well documented and because they have been, until recently, readily available to researchers, they are probably the most frequently published pictographs of the Custer battle.[104]

In his narrative, Red Horse set the scene for the events depicted in Fig. 20:

> That day was hot. In a short time the soldiers charged the camp. . . . The women and children ran down the Little Bighorn river a short distance into a ravine. The soldiers set fire to the lodges. All the Sioux now charged the soldiers and drove them in confusion across the Little Bighorn river. . . . [105]

Fig. 20[106] shows Reno's column which has turned to retreat back over its own trail. The drawing shows three separate sets of orderly tracks belonging to the

---

[102]Mallery, "Picture-Writing of the American Indians," p. 56.

[103]Red Horse's drawings are all made with colored pencils on large sheets of heavy manila paper averaging 24 x 36 inches. The Red Horse series is part of the collections of the National Anthropological Archives, Smithsonian Institution, Washington, D.C. The catalog number is 2367-a. Because of the poor condition of the drawings, they are now unavailable to researchers. Poor-quality copy prints in both color and black and white are available from the Office of Photographic Services. Negative numbers may be obtained from the NAA/SI.

[104]Several Red Horse drawings have been published in Jordan, "Ghosts on the Little Bighorn." Two Red Horse drawings, including one not reproduced in this study (warriors leaving the battlefield with cavalry horses), appear in Charles Wills, *The Battle of the Little Bighorn,* a not-too-factual elementary-level textbook. Two Red Horse drawings also appear in Welch, *Killing Custer.* A sign language version of Red Horse's narrative, also recorded by Dr. McChesney, appears in Jessie Brewer McGraw's book for children, *Chief Red Horse Tells About Custer.*

[105]Mallery, "Picture-Writing of the American Indians," p. 565.

[106]The Red Horse drawings shown here as Figs. 20–28 are from slide transparencies, provided by courtesy of the National Anthropological Archives, Smithsonian Institution, of Red Horse drawings numbers 12, 14, 15, 16, 17, 18 19, 11, 13 respectively.

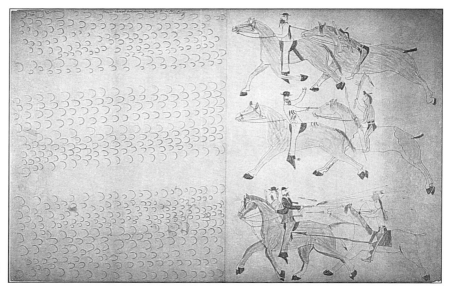

Figure 20

three companies who had ridden into the valley under Reno's command. The tracks are neatly drawn, probably indicating the orderliness of Reno's first approach to the village.

While on the skirmish line in the valley, a trooper had reported to Reno that Indians were firing upon the rear of the column.[107] Reno ordered his men to withdraw to a stand of timber along the river. The retreat, temporarily interrupted by that short interval in the trees, had begun in an orderly fashion, but quickly assumed the character of a rout and a race for safety.[108]

At the top of the drawing, a warrior with a long lance counts coup on a white-man rider and stabs him in the

[107]Morris and Mangum, ed., "Reno's Battalion in the Battle of the Little Big Horn," p. 5.
[108]Dodge, *The Plains of the Great West*, p. xxxv; Herendeen, *New York Herald*, in Graham, *The Custer Myth*, p. 308.

**80**

back. In the center, a wounded white man wearing spurs with rowels turns in his saddle to fire at an Indian carrying a spiked war club and a long lance. The warrior rides a horse with painted lightning stripes on its forelegs and rump. The shape of the white man's wounds matches the spikes on the war club, and his horse has a matching wound as well. At the bottom of the drawing, a soldier riding alongside another white man fires a hailstorm of bullets at a pursuing Indian wearing a white man's hat and armed with a bow. The soldier has been badly wounded; he has a lance wound in the thigh and arrows in his back, with another arrow headed toward him. The white man with his back to the warrior is concerned only with escape.

Red Horse drew in the details of a uniform on the soldier, clearly identifying him as such. But the plain clothing of the other three white men may indicate that these men were civilians, or at least men wearing different types of non-uniform clothing.

The assault on Reno's retreating column is taking its toll. In Fig. 21, six riderless horses race along with Reno's men. Three dead soldiers lay on the ground. A warrior with a spiked war club and a spear lances a fleeing soldier who does not discharge his carbine or defend himself in any way.

The horse tracks on the right are still in three groupings, but are slightly less orderly than in the previous drawing. Reno's soldiers, still apparently riding by companies, are retreating, leaving behind the ordered marks of their passing. Their ranks are being thinned by pursuing warriors.

Fig. 22 depicts Reno's retreat from the valley. At the top of the drawing, a warrior with a long, horned war bonnet fires at a badly wounded soldier rushing to es-

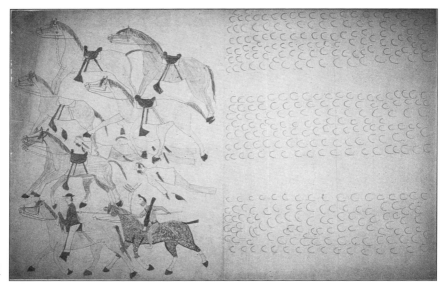

Figure 21

cape on his wounded horse. Nearby, another wounded soldier is closely pursued by a warrior with a carbine; the soldier has been shot through the back and chest, and his horse has been wounded in two places. Neither soldier makes any attempt to defend himself.

The tracks left behind are somewhat orderly, but more widely spaced, indicating increased speed. There is no longer any sign in the tracks themselves of soldiers riding in company groupings.

Fig. 23 depicts Reno's retreat from the valley. At the top of the drawing, a yellow-painted warrior fires arrows at a badly wounded soldier who is pulling an arrow from his eye. In the center of the drawing, a warrior with a red cape and long war bonnet lances a soldier in the back. At the bottom, a warrior with a bow takes aim at a fleeing soldier.

82

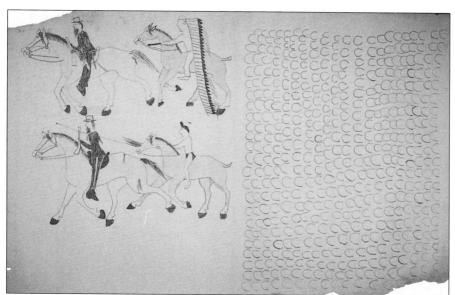

Figure 22

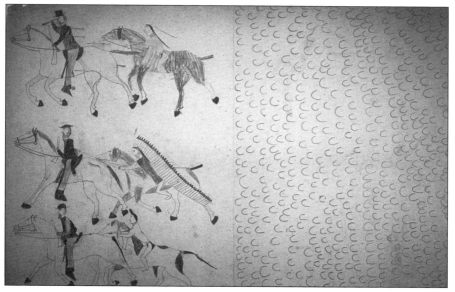

Figure 23

The manner in which horse tracks are laid down can give an experienced, observant tracker a lot of information. The knowledge gained from a lifetime of reading horse tracks was translated by Red Horse into drawings which show us what he observed at the actual scene, and what he thought the signs meant. In this drawing, not only do the horse tracks no longer show any semblance of column formation, the orderliness is also gone. The tracks have been made by horses running along no set trail, and at various speeds. In some places, the tracks show bunching and crowding.

In Fig. 24, warriors follow soldiers riding at the end of Custer's column. The tracks are divided into five overlapping sets, a pattern which would have resulted only when the five companies under Custer's command rode together. The only time Custer's *five* companies (C, E, F, I, and L) were all together as a full, mounted, orderly group was before they had diverged somewhere in Medicine Tail Coulee. I believe Red Horse drew the horses' tracks in just this pattern as an indication that he had observed in person then, or by signs afterward, the separation of Custer's five companies.

In the drawing, the tracks are drawn in one body. Then three groups are crossed out, leaving two still intact. As far as I have been able to determine, the only occurrence matching this depiction was when Custer's command split, with some companies (probably two) riding down Medicine Tail Coulee toward the river, and some companies (probably three) riding up out of the coulee toward Nye-Cartwright and Calhoun Ridges. This drawing seems to indicate an attack made on a two-company grouping, or on five companies which have recently made divergent/ convergent trails.

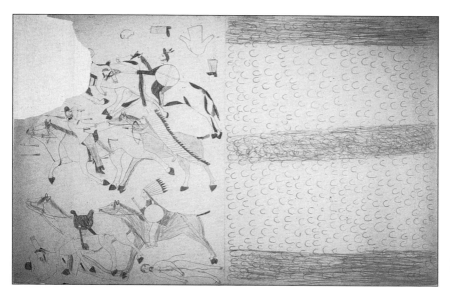

Figure 24

All the cavalry horses in this drawing are pink. Cos. E and F, thought by some to have been the two companies which rode toward the river, rode gray and bay horses, respectively. The color pink here could represent F Co.'s bay horses. The gray horses of Co. E were said to have been stampeded later elsewhere on the battlefield, leaving their riders afoot.

I believe this scene shows one of two possibilities: either Co. F (riding behind Co. E) is being attacked while leaving Medicine Tail Coulee ford; or the tail end of all five of Custer's reunited companies is being attacked just as all the companies have reunited near Calhoun's position.

In this drawing, a warrior riding a pinto and carrying a shield shoots a soldier. An Indian in a long, horned war bonnet shoots arrows at a soldier, wound-

ing him in the face. Another warrior in a war bonnet, cape, and painted leggings, and carrying a shield and carbine, has lanced a soldier. The stripped body of a soldier is on the ground, and human body parts are visible at the top of the drawing.

In Fig. 25, the ground is littered with flags and bugles. One wonders if the Indians made a special point of killing buglers in order to destroy the command's ability to relay orders to the companies of Custer's columns. Once separated by terrain and hordes of warriors, and without buglers, the company commanders would have found it difficult if not impossible to relay orders. Any isolated companies would then have been forced to act more or less independently. The Indians testified that single soldiers darted around between some of the company positions; these soldiers may have carried messages.

In the drawing, some of the dead have been stripped, dismembered, and decapitated. In the center of the right half of the drawing, an Indian on a yellow horse shoots a soldier in the mouth with an arrow. Another soldier carrying a flag flees across the field. A warrior in a long war bonnet, with long fringes or ermine-tail streamers on his sleeves, lances a wounded bugler who has been shot with an arrow through the leg. Nearby, a soldier with chevrons on his sleeve falls from his horse. At the upper right, a warrior with a long, horned war bonnet tumbles a soldier off his horse. At the lower right is a dead man in civilian apparel. Civilian relatives, scouts and a newspaper reporter, all probably wearing non-military clothing, rode with Custer's group.

The running battle depicted in Fig. 26 leaves dismembered and decapitated dead in its wake. In the

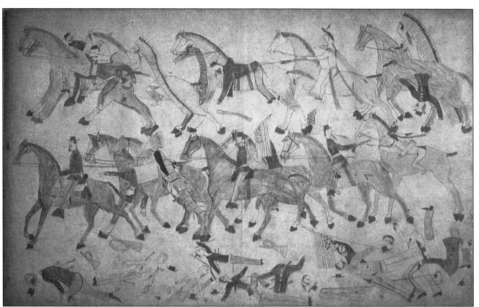

Figure 25

upper left corner of the drawing, a soldier who has been shot in the thigh and wounded in the back falls from his horse. Below, a warrior stabs a soldier in the throat and prepares to scalp him. To the right, a warrior wearing a horned headdress and carrying a shield and a saber attacks a mounted trooper. This warrior rides either a spotted horse, or a horse specially painted with hailstone spots. Farther to the right, a warrior in a war bonnet shoots a soldier in the mouth. At the bottom of the drawing, a warrior with a long war bonnet and carrying a saber pursues a soldier who shoots at him without turning around to aim. Other soldiers rush to escape the warriors riding in their midst.

Fig. 27 shows wounded and dismembered soldiers. At the top of the drawing, a warrior in decorated leg-

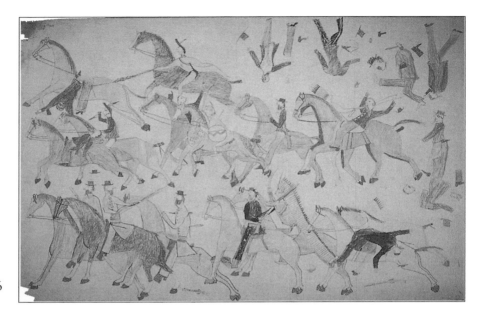

Figure 26

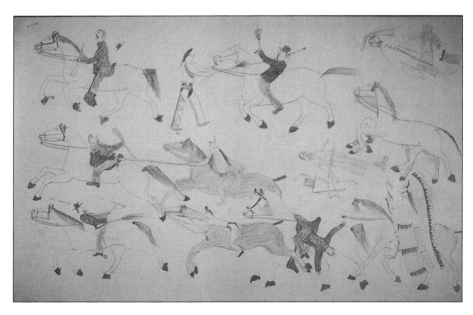

Figure 27

gings and a bandolier cartridge belt shoots a soldier in the face as the trooper fires his weapon uselessly in the air. In the center of the drawing, a yellow-painted warrior with a cape and a horned headdress with ermine-tail streamers lances a bearded soldier in the thigh. In the lower right corner of the drawing, an Indian in a long, horned war bonnet and carrying a shield with a long, feathered streamer, and holding a spiked war club joins the battle. At the bottom of the drawing, a warrior pursues a wounded soldier bending low over his horse. The soldier fires his carbine at the warrior.

In the upper right corner of Fig. 28, a warrior with painted or beaded leggings shoots arrows at a soldier wounded in the back and leg; other arrows miss their mark and fly by. In the center of the right half of the drawing, a warrior with a shield and riding a pinto shoots at soldiers who shoot back without turning around to aim. In the lower right corner, a wounded white man in civilian dress is losing his battle with a warrior dressed in a war bonnet and painted cape; nearby, another soldier attempts to escape on his wounded horse. Three riderless cavalry horses lead the retreating group.

According to Fox,

> Red Horse's recollections lack spatial and temporal clues altogether; they are unintelligible without reference to independent sources such as those available from archaeology.[109]

It is not clear if Fox is referring here to Red Horse's narrative only, or to his drawings, or to both. Certainly Fox's comment can be applied to many Plains Indian pictographic drawings, since concepts such as space and time are essentially non-existent constructs in this

---

[109]Fox, *Archaeology, History, and Custer's Last Battle,* p. 152.

type of art. Plains battle art was *never* meant to stand alone; its contemporary and cultural validation and expression depended absolutely upon the public retelling of the events portrayed. The storyteller knew where the action had taken place, and when, and made his audience aware, too.

Red Horse's drawings do not "lack spatial and temporal clues." In the ways he has drawn the tracks of Reno's column, Red Horse has left us information on both the general location of the scenes depicted and their chronological sequence. On the way down the valley toward the villages, the tracks are in three neat, orderly groupings, indicative of an advance made by three companies in good order. After the order to remount to withdraw from the position on the dismounted skirmish line in the valley, the tracks, still in three groups, are farther spaced and less ordered, indicative of greater speed and beginning anxiety. Farther from the village, but still on the west side of the river, the tracks are no longer arranged orderly in three groups, and are much wider spaced. This is indicative of an every-man-for-himself pace, accompanied by a high degree of panic. Red Horse's drawings, in my opinion, provide plenty of clues for all to see what happened in the parts of the battle he portrayed.

The pictographic drawings of the battle of the Little Bighorn can be linked satisfactorily to both Indian and non-Indian testimony, and in turn, this information was largely confirmed by the archaeological evidence literally turned up as an indirect result of that fortuitous grassfire. I do not agree, however, that archaeological evidence is the sole supporting pillar of the information contained in these drawings.

I also believe that there are enough visual clues in

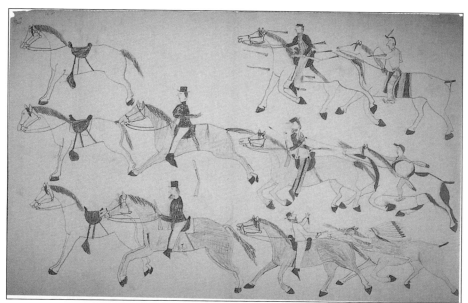

Figure 28

Red Horse's drawings to refute Maurer's assertion that these drawings are mere "generic descriptions of the action rather than accounts of specific events."[110] The number of columns portrayed by the different sets of horse tracks, and the manner in which Red Horse has portrayed them very clearly state who is portrayed in the drawings and where the actions occurred. And because we know the rough time frame for the events portrayed, the question of when the events happened is also answered. When viewed sequentially, in the order adopted here, the Red Horse drawings of the soldiers, especially Reno's soldiers, clearly show the progression from advance to retreat, from offense to defense, from order to disorder, from unity to disunity, from confidence to panic, from group to individuals.

---

[110]Maurer, *Visions of the People*, p. 200.

**91**

## Little Wolf

Little Wolf was an able and respected Northern Cheyenne leader. He and his band of followers did not reach the camps on the Little Bighorn until shortly after the Custer battle, so Little Wolf himself did not participate in the Reno fight in the valley or in the fight against Custer. Little Wolf or his followers may have fought against the Reno and Benteen men entrenched on the bluff. The drawings from this ledger which have been included in this study concern events in which Cheyenne warriors participated.

The Little Wolf band ledger book is privately owned and is currently on loan to the Foundation for the Preservation of American Indian Art and Culture, in Chicago. None of the relevant drawings from this ledger book have been illustrated in this study.

The ledger contains 122 watercolors showing the exploits of several different warriors. Since I have not had the opportunity to see the ledger or illustrations of every drawing contained in it, it is impossible for me to know if all the drawings in the ledger were executed by the same artist. It is possible that more than one artist worked on the drawings as such cases have been documented. The drawings discussed here do seem to have been drawn by a single artist.[111]

The Hunkpapa camp was at the extreme southern end of the great encampment. Some of the tipis were

---

[111]Many of the scenes in the Little Wolf ledger have been reproduced in Powell, *People of the Sacred Mountain.* Powell designated the ledger "The Little Wolf Ledger" years ago because of Little Wolf's prominence in the paintings. The actual artist is an as-yet-unidentified Northern Cheyenne. Personal communication from Peter Powell, Aug. 22, 1998.

pitched near the big trees along the river. Reno's soldiers came on the village at a gallop, getting close enough to shoot into the camp[112] and set fire to some of the tipis on the edge of the village. A number of Indian women and children were killed there.

One drawing in the Little Wolf ledger[113] depicts two unmounted soldiers armed with Springfield carbines walking away from a stand of trees. There are fan-shaped sprays depicted in the upper left corner of the drawing representing bullets being fired, probably from the trees, toward the camp. Although soldiers are depicted here, it is possible that Reno's Arikara scouts killed[114] the two women, two girls, and a baby, shown falling out of a beaded cradleboard, depicted in this drawing. These were wives and children of Gall, who was camped with Sitting Bull's Hunkpapas at the time of Reno's attack,[115] and who was one of the principal leaders in the Custer battle. Gall was so angered at the killing of his family that he reportedly went into battle that day with a hatchet so he could inflict as much pain as possible upon his enemies.[116]

One of the dead women is shown with unbraided hair. This may indicate that one of Gall's wives was not Sioux, or that she had her hair unbraided or cut short in mourning for someone recently dead. On the ground near the bodies, there are several marks resembling scuffed footprints and blood.

---

[112]McLaughlin, *My Friend the Indian*, p. 146.

[113]Powell, *People of the Sacred Mountain*, p. 969.

[114]Herendeen, *New York Herald*, 8 July 1876. Herendeen states that it was the Arikara scouts, not soldiers, who were responsible for killing the Indian women and children; see also Hardorff, *Lakota Recollections*, note, p. 94.

[115]Powell, *People of the Sacred Mountain*, p. 968.

[116]Ibid.

Another drawing in the Little Wolf ledger[117] shows the presence of pack mules, so this drawing depicts an event that occurred after Benteen and the pack train had joined Reno's group on top of the bluff on the eastern side of the river. The soldiers shown here have taken cover and are shooting at warriors on the opposite bank. A badly wounded trooper is in the river. The Indians are firing back at the soldiers, who are providing fire cover for the wounded soldier. Iron Hawk, a Sioux warrior, related that Indians were stationed near the river banks to prevent soldiers from getting water.[118] Wooden Leg, a young Cheyenne man, was hiding near the river where the soldiers came down to fill their canteens. Wooden Leg shot and wounded one of the soldiers, who was later killed by a Sioux warrior.[119]

Before going to fight against Reno, Wooden Leg had painted his face with a blue-black charcoal circle which enclosed his face, with the interior colored red and yellow, and his hair worn somewhat loosely.[120] One of the warriors shown at the right, either the one at the top or the one at the bottom with a similar paint pattern and hairstyle, is probably Wooden Leg.

In the drawing, horse tracks leading up the hill show the route used earlier by Reno's soldiers when they fled across the river and scrambled up the steep bluffs. When Benteen and his column appeared at the edge of the bluffs, they met the last of Reno's stragglers clawing their way up the slopes.

---

[117]Ibid., p. 971.

[118]Miller, *Custer's Fall*, p. 166.

[119]Marquis, *Wooden Leg*, pp. 259-60. The dead man was identified as Tanner of Co. M.

[120]Ibid., pp. 218-19; Connell, *Son of the Morning Star*, p. 301.

The other tracks do not belong to horses and indicate a path used by the Reno and Benteen soldiers who volunteered to go down to the river for water. The volunteers made several trips.

After the Custer battle, the Indians returned to where Reno had taken up a position on the bluffs, and fired upon the soldiers there with weapons captured from the dead soldiers downstream. When some soldiers volunteered to go to the river after water, several soldiers known as expert marksmen were detailed to protect the water carriers[121] from Indians firing from the opposite bank of the river. In the drawing, one of the soldiers and all of the Indians are using .45 caliber Springfield carbines, but the other two soldiers on the hill and the one in the river have different weapons, possibly Springfield rifles.

A third drawing from the Little Wolf ledger[122] shows four men who were killed very near the river. The dead men pictured here are probably some of Reno's men killed during the retreat from the valley, since horse tracks are shown emerging from the trees. Indians reported that some white men who were hiding among the trees near the river were discovered and killed.[123]

This drawing shows a dead cavalry horse, indicated

---

[121]Brininstool, *A Trooper with Custer,* p. 181.

[122]Powell, *People of the Sacred Mountain,* p. 977.

[123][Marquis], *Custer of the Little Bighorn, Thomas B. Marquis: Eye Witness and Carefully Researched Accounts of Custer's Famous "Last Stand" Battle,* p. 34. Photographs taken in 1886 suggest that, although there certainly were cottonwoods along at least the western bank of the Little Bighorn, there were not as many trees, nor were they as large, as are the trees there today. See George E. Gruell, *Fire and Vegetative Trends in the Northern Rockies: Interpretations from 1871–1982 Photographs,* pp. 101, 102, Pls. 83 a and b, 84 a and b.

by the iron horseshoes, and the four dead men. All of the men have been stripped. Two of the men have been scalped, and one has been beheaded. A knife is imbedded in the chest of one, and in the mouth of another. The skin of three of the dead men is colored a pale yellow, indicating white men. But the skin of the beheaded man is dark. His hair is long, and he has what may be the cord of a loincloth around his waist.

The headless man could be Isaiah Dorman, a black scout who rode with Reno's column, and who was killed between the timber and the river.[124] Dorman had formerly lived with the Sioux. The Sioux were angry when they saw a former friend riding with the soldiers. During Reno's retreat, Dorman's horse was shot, and it fell over onto its back. Dorman could not get up and was soon killed.[125] The Oglala Sioux Eagle Elk told of a wounded man sitting on the ground, who had been shot by a woman with a pistol. The man reportedly said to the woman, "Do not kill me, because I will be dead in a short while, anyway." This man was Isaiah Dorman. Eagle Elk identified the Hunkpapa woman who killed Dorman as Eagle Robe.[126] The Arikara scout Young Hawk, who saw Dorman's body, said the Sioux had badly mutilated it.[127] The headless body could also be that of the Arikara scout Bloody Knife, who was killed just before Reno's men left the timber. The Sioux reportedly beheaded Bloody Knife and paraded his head through the village. However,

---

[124]Hammer, *Custer in '76*, p. 135; Herendeen, *New York Herald.*

[125]Dixon, *The Vanishing Race: The Last Great Indian Council*, pp. 172, 173.

[126]Hardorff, *Lakota Recollections*, pp. 101, 102, note p. 102.

[127]Libby, ed., *The Arikara Narrative of the Campaign Against the Hostile Dakotas June, 1876*, p. 110; McLaughlin, *My Friend the Indian*, p. 13.

none of the artists of any of the drawings in this study have felt the need to apply color to the bodies or torsos of Indians, except when indicating body painting. I believe the dark coloring on this individual surely indicates a person out of the ordinary, a "black white man," and the only such man on this expedition was Isaiah Dorman.

The dead and dying cavalrymen pictured in another drawing from the Little Wolf ledger[128] include six enlisted men, and one officer with shoulder boards, shown at left center. Two dead cavalry horses sprawl nearby. The horse tracks at the bottom indicate that the soldiers were overtaken by pursuing Indians. One soldier with a company flag fires six shots into the air with his revolver. Perhaps he is firing a volley of shots.[129]

Two dead warriors, both probably Cheyenne, lie among the soldiers. One, in a long war bonnet with ermine tail decorations, reaches out with a quirt which he has probably been using as a coup stick; he has been killed in the attempt to count coup on the enemy. He has been shot in the chest and is bleeding from the mouth. His firearm is a different type than that carried by the soldiers. The troopers carry Springfield carbines, model 1873. The Cheyenne's weapon is probably a Winchester model 1866 carbine. The Indians referred to this weapon as a "Yellow Boy."[130] A dead Indian pony is in the lower right corner.

---

[128]Powell, *People of the Sacred Mountain*, p. 979.

[129]Hunt, *Custer, The Last of the Cavaliers*, pp. 200-01. Slow, deliberate volley firing could have been Custer's final signal of distress. Volleys were heard by Reno's men, and Curley saw volleys being fired from near the Calhoun positions.

[130]Scott and Fox, *Archaeological Insights into the Custer Battle*, p. 73. The Winchesters were brass-plated, hence the name, "Yellow Boy."

During the Reno Court of Inquiry, many soldiers testified that the Indians had used repeating Winchesters and Henrys against them. These statements were considered inaccurate by later researchers who could find little proof that the Indians had possessed enough superior weapons to cause any substantial damage. In fact, early metal detector finds on the battlefield seemed to disprove the presence of these rapid-fire weapons.[131] The Indian drawings, however, do show repeaters. The archaeological survey made almost twenty years ago on part of the Custer battlefield supports the use of *some* superior weapons there by the Indians.[132] But the firearms-use scenarios drawn up after the survey were based largely upon ammunition finds. Indian collection of shells as well as guns immediately after the battle, and relic hunting in the years since the battle, obviously removed many items from consideration in these statistical profiles. There could have been more Winchesters and other repeaters used in the battle than the studies show.

Fox theorizes that the troopers began to panic when they realized that some of the Indians possessed repeaters.[133] In his 1930 interview with Walter S. Campbell, the Minneconjou White Bull referred to his Winchester as the "seventeen loading-gun."[134] The presence on the battlefield of *any* Winchester repeaters would have caused at least some panic among men armed with single-shot carbines and six-shot revolvers, especially among recruits lacking the confidence to effectively use either under pressure.

---

[131]DuMont, *Custer Battle Guns*, p. 54.

[132]Scott and Fox, *Archaeological Insights into the Custer Battle*, pp. 73-74.

[133]Fox, *Archaeology, History, and Custer's Last Battle*, p. 253.

[134]In Hardorff, *Lakota Recollections*, p. 108.

In this drawing, the weapon of the other dead warrior is on the ground at his feet, and seems to be a lever-action repeater. This warrior lies near a dead Indian pony. This horse has no horseshoes, no saddle, and has one of the silver bridles so highly prized by the Cheyenne. The horse's tail, not quite visible in the drawing, is tied up. This was generally done by Plains warriors in preparation for a battle. In pictographs, a tied-up horse tail often signified that the rider had time to prepare for a battle. In a surprise attack, warriors did not have time to tie up horse tails. An examination of some of the drawings of Reno's attack in the valley shows that many of the Indian ponies depicted have loose, streaming tails, indicative of the surprise attack made there. The Indians testified that some men took their time in joining the Reno battle, while others went immediately, without any of the traditional preparations.

Not until the Cheyenne had traveled far from the battlefield and were certain they were not being pursued did they stop to celebrate their victory. As part of their celebration, they erected a red and black victory pole and staged a scalp dance,[135] the event portrayed in another drawing in the Little Wolf ledger.[136] A hand and scalp are shown dangling from the top of a pole. The long-haired scalps seen here are probably from the dead Arikara or Crow scouts. In the drawing, two women carry scalps on long sticks, and another carries a severed hand. Antelope Woman, also known as Kate Bighead, was a Cheyenne woman who watched the Custer battle. She later reported that she had seen

---

[135]Powell, *People of the Sacred Mountain*, p. 980.
[136]Ibid., p. 981.

people cutting off soldiers' arms, legs, and feet to use as trophies for the victory dances.[137] John Stands in Timber said that people who had had relations killed at Sand Creek chopped off heads and arms from Custer's dead, since that was what had been done to the Cheyenne there.[138]

The faces of the women and the male drummers on the left side of the drawing are painted black for victory. The hair of one of the women is unbraided. This probably indicates that she was in mourning for someone recently dead, probably killed in the Little Bighorn battle, or in the earlier encounter with Crook. When women grieved for the dead, they would unbraid their hair, rub dirt and ashes into it, or even cut it short. Men often did the same.

The figures in the drawings in the Little Wolf ledger are larger and more clearly drawn than most of the other pictographs included in this study. The Little Wolf drawings document events not shown by the other artists here. They are also ununsual in that some of the drawings show no warrior-protagonist.

---

[137]Marquis, "She Watched Custer's Last Battle," in Powell, *People of the Sacred Mountain*, p. 1029.

[138]Stands in Timber and Liberty, ed., *Cheyenne Memories*, p. 205. The Sand Creek Massacre occurred in 1864 in what is now southeastern Colorado. A peaceful Cheyenne camp under Black Kettle was attacked by a large force of 100-day volunteers and town rowdies interested mainly in killing Indians and taking trophies. Most of the casualties there were women and children, who were also the victims of numerous atrocities.

## White Bird

At the time of the battle of the Little Bighorn, White Bird, a Northern Cheyenne, was a boy of about fifteen.[139] He rode with the warriors who crossed the river to keep Custer's column away from the lower end of the village.

Between 1894 and 1895, White Bird produced three drawings of the battle of the Little Bighorn. The drawings were painted on muslin for Captain Richard L. Livermore, and are now part of the collections of the West Point Museum at West Point, New York.[140] White Bird's drawings represent his own recollections of the battle, as well as those of his contemporaries.

Fig. 29[141] is a detail of a larger drawing of Reno's retreat, showing mounted warriors and soldiers racing across the field. At the top of the drawing, a warrior wearing a long war bonnet and holding a spiked war club is shot off his horse by a soldier. Below, a mounted Cheyenne warrior with a war bonnet runs down an unmounted soldier.

At the top of this drawing, a warrior in a long war bonnet shoots two soldiers from their horses. On the right side, a Sioux warrior wears the feathered cap with ermine tail streamers, and feather-decorated sash worn by members of the Strong Heart soldier society.[142]

---

[139]Blish, *A Pictographic History of the Oglala Sioux,* p. 19.

[140]Blish, in ibid., incorrectly lists the catalog numbers of the White Bird material at the West Point Museum as 1207, 1208, and 1209; the correct numbers are 406, 407, and 408.

[141]Photograph courtesy of West Point Museum Collections, United States Military Academy.

[142]Sitting Bull was a member of this society, but he probably did not participate in the fighting at the Little Bighorn as he was considered to be past the age for active warfare. See Vestal, *Sitting Bull,* p. 27 for a description of this society's regalia.

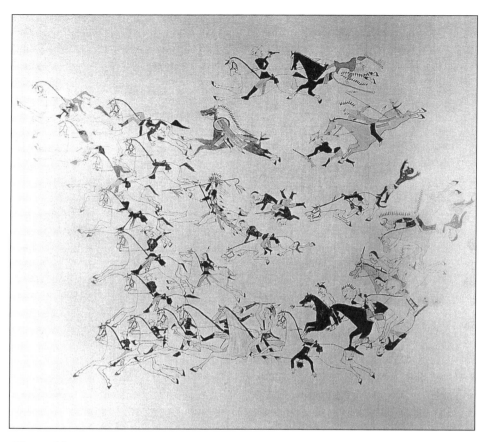

Figure 29

In the lower right corner of the drawing, a succession of mounted warriors pursues a group of soldiers, some of whom fight back. Riderless horses run alongside.

The third figure down on the right side of the drawing is a black man wearing a pair of uniform trousers. This figure represents Isaiah Dorman, the black scout and in-

terpreter who rode with Reno's column. The Indians tell of a black man in a soldier's uniform who, during Reno's retreat, turned in his saddle and shot a warrior riding next to him. Then the black man's horse was killed, throwing his rider to the ground.[143] Private Roman Rutten, one of Dorman's friends, reported seeing Isaiah on one knee near his dead horse, firing carefully with a non-regulation sporting rifle.[144] Dorman's body was later found along Reno's retreat route from the valley.

The Little Bighorn River is shown in Fig. 30,[145] at the bottom of the drawing. At the far right is Reno Creek, down which Reno's column advanced on its way to the valley. The stream or ravine running diagonally in the center is probably Medicine Tail Coulee. On the day of the battle, the Cheyenne camp was situated directly across the river from the mouth of this coulee.

The rest of the camp stretches away to the south. White Bird has shown six distinct camp circles rather than the five usually described in most accounts of the battle. The drawing also shows that the camp was not in flight when Reno attacked for the tipis had not been taken down.

The tracks of Reno's column proceed down and across Reno Creek, and then across the Little Bighorn. More tracks mark his attack on the southern end of the village and his retreat into the timber. Ca-

---

[143]Tillett, *Wind on the Buffalo Grass*, p. 80.

[144]Connell, *Son of the Morning Star*, p. 26. Some sources give a different spelling for Rutten; it also appears as Ruetten.

[145]White Bird's drawings appear in Utley, "The Custer Legend"; Monaghan, *The Life of General George Armstrong Custer;* Scott and Conner, "Postmortem at the Little Bighorn"; Jordan, "Ghosts on the Little Bighorn"; and Tillett, *Wind on the Buffalo Grass.* Note that Tillett artificially compacted the drawings to fit his formats. Photographs courtesy of West Point Museum Collections. This White Bird drawing is painted on muslin, and is approximately 47 x 89 inches.

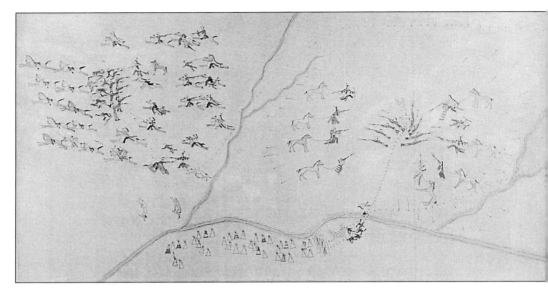

Figure 30

sualties line his retreat route from the timber back across the river.

The remains of the tipis set on fire during Reno's attack are clearly seen at the right edge of the village. A faint circle nearby marks the timber to which Reno withdrew, and the tracks within mark the time spent there and the positions assumed by Reno's dismounted soldiers. The fact that White Bird shows Reno using the same ford for his attack as well as his retreat shows that Reno's approach to the village was not observed by White Bird, and that Reno's men were not seen by most of the Indians, at least those in the camps below the Hunkpapas, until the sudden appearance of the soldiers close to the southern end of the village. Dozens of Indians "accompanied" the soldiers to the retreat ford, and so, as the specific location of a well-attended fight, was familiar to many.

**104**

The path of Reno's retreat is marked by dead soldiers; the route across the river and up to the bluff top is illustrated by the body of a soldier in the river and by the body of a dead scout. The horse tracks lead to Reno's position, a small hollow around which Reno's exposed soldiers lay. A small cluster of horse tracks above the prone soldiers marks the site of the field hospital where Reno's wounded were shielded from hostile fire by the horses tethered there. Low Dog, a Sioux, reporting on Reno's attack, and then Custer's, said,

> We drove the first attacking party back, and that party retreated to a high hill....By this time all the warriors in our camp were mounted and ready for fight, and then we were attacked on the other side by another party. They came on us like a thunderbolt.[146]

Reno's bluff position was exposed to hostile fire mostly from the north and south. Benteen's troops held the most exposed positions, and they had to make repeated charges to drive the Indians away from the perimeter. In this drawing, the Indians are armed with bows and various firearms. Their horses are tied to their waists. In the drawing, one warrior on the left (north) side of the Reno group rests his carbine on a pair of crossed sticks, a steadying device for firing. In 1877, a battlefield visitor noted a set of such sticks on the hill on the north side of Reno's position.[147] Reno's besieged soldiers reported that Indian sharpshooters on the north side of their position did a great deal of harm to those soldiers positioned thinly along the northern perimeter. The soldiers there reported that

---

[146]*Leavenworth Weekly Times,* "The Stories of Low Dog, Crow King, Hump, Iron Thunder."

[147]DuMont, *Custer Battle Guns,* p. 45.

another of the Indian sharpshooters was seen resting his gun upon an old buffalo skull.[148]

Thousands of arrows were found on the Custer battlefield, but few men with Reno and Benteen mentioned that arrows were used against them. The Indians had captured plenty of carbines, revolvers, and ammunition from Custer's men, and used these weapons against the Reno command.[149] According to Amos Bad Heart Bull, over seven hundred firearms were collected after Reno's fight in the valley and after the Custer fight.[150]

The soldiers suffered greatly from the sharpshooters and the seemingly superior weapons of the Indians. Lieutenant Charles De Rudio reported seeing the cavalry bullets strike short of the Indians, while the Indians' bullets whistled over the soldiers' heads.[151] Three Indian marksmen in particular evidently gave the men on the line a great deal of trouble. The Indians occupied a position behind some rocks and until they were silenced by soldier sharpshooters, their shots rarely missed.[152] Captain Thomas French had a long-range infantry Long Tom, and First Sergeant John Ryan had a non-regulation, specially outfitted Sharps rifle with a telescope. After a few shots from these two, the Indian sharpshooters abandoned their position.[153]

---

[148]Mangum, ed., "Battle of the Little Big Horn, as Related by Charles Windolph," p. 5. Windolph was a member of Co. H.

[149]Marquis, *Keep the Last Bullet for Yourself: The True Story of Custer's Last Stand*, p. 144.

[150]Blish, *A Pictographic History of the Oglala Sioux*, p. 272.

[151]Hammer, *Custer in '76*, p. 85.

[152]Magnussen, ed., *Peter Thompson's Narrative of the Little Bighorn Campaign, 1876: A Critical Analysis of an Eyewitness Account of the Custer Debacle*, p. 219.

[153]Morris and Mangum, ed., "Reno's Battalion in the Battle of the Little Big Horn," p. 5; John Ryan, in Graham, *The Custer Myth*, pp. 244-45; Sandoz, *The Battle of the Little Bighorn*, p. 138.

The Indians surrounding Reno's position kept up a heavy and steady fire. Lieutenant Varnum said that at times the Indians' fire made a single line of smoke around the whole position. Sometimes the troops would make no reply and the Indians would suddenly rush the soldiers. The troopers would open fire then and drive the Indians back. Occasionally, a warrior would ride up too close to the line.[154] Long Robe, a Sans Arc Sioux, rushed up to the soldier position to count coup on a dead soldier, but he was killed. His body fell so close to the soldiers that his friends were unable to retrieve it.[155] In the drawing, the single dead Indian on the south side of the Reno position probably represents Long Robe. There were evidently no mounted charges against the soldiers entrenched on the bluff, but several warriors did distinguish themselves by personal acts of bravery and daring.

Tracks across the top of the drawing indicate the route Custer and his column followed after separating from Reno and Benteen. The drawing indicates that Custer passed well behind Reno's later position on the bluff top.

George Bird Grinnell, a tireless scientist and ethnographer, spent many years among the Cheyenne, recording their history and culture. Some of his informants stated that they knew that the troops had separated on Reno Creek, and that an old man had warned the people that the soldiers were about to charge the camp from both the upper and lower ends.[156] But, ac-

---

[154]Stewart, *Custer's Luck*, p. 421; Pohanka, "Their Shots Quit Coming," *Greasy Grass*, p. 13.

[155]Miller, *Custer's Fall*, p. 188; Vestal, *Sitting Bull*, pp. 176, 178; Connell, *Son of the Morning Star*, p. 60. The dead Sioux warrior has also been identified as Long Road and Long Bow.          [156]Sandoz, *Crazy Horse*, pp. 324-25.

cording to Thomas Marquis who interviewed many of the Indian survivors of the battle, the Indians were unanimous in their statements that the Custer group was first seen moving at a trot on a long, high ridge running almost parallel to the river.[157] Gall, one of the most prominent Sioux leaders at the battle, described Custer's approach as "the parade across the river to our east."[158]

Custer's command seems to have been overly and purposefully visible. Custer almost certainly meant to decoy the Indians away from the camp so Reno's attack could succeed in forcing the Indians to fight on two fronts at once. From his vantage point on the ridge, Custer must have been able to see for himself that the residents of the huge village were not in full flight. He also might have been able to observe that Reno was meeting very strong resistance. The cryptic "Come on. Big village. Be quick!" message sent to Benteen gives us a feel for Custer's sense of urgency in reuniting his command.

In the drawing, Custer's tracks come partly down Medicine Tail Coulee, then turn sharply east, out of the ravine, moving along toward the site of the present-day monument. In this drawing, the tracks do not reach the river.[159]

Mounted and dismounted Indians on foot storm Custer's soldiers.[160] By now, each company has experienced the loss of most of its members. The Indians chase individual survivors to the site of the final resis-

---

[157]Marquis, *Keep the Last Bullet for Yourself,* p. 99; Vestal, *Sitting Bull,* p. 167.

[158]Barry, *Indian Notes on "The Custer Battle,"* p. 9, in Stewart, *Custer's Luck,* p. 347.

[159]McCreight, *Chief Flying Hawk's Tale: A True Story of Custer's Last Fight, as Told by Chief Flying Hawk,* p. 29.

[160]Stewart, *Custer's Luck,* p. 450.

tance. A figure which could be Custer, identifiable by the buckskin jacket, lies to the left of the group of soldiers. Riderless cavalry mounts race off to the right. Crow King, one of the Sioux leaders in the battle, described this portion of the battle:

> The greater portion of our warriors came together in their front and we rushed our horses on them. At the same time warriors rode out on each side of them and circled around them until they were surrounded. When they saw that they were surrounded they dismounted. They tried to hold on to their horses, but as we pressed closer they let go their horses. We crowded them toward our main camp and killed them all.[161]

Julia Face, an Oglala Sioux woman who watched the Custer battle, said, "The Indians acted just like they were driving buffalo to a good place where they could be easily slaughtered."[162]

At the part of the drawing where Custer's tracks turn sharply eastward, a mounted soldier races to the right toward Medicine Tail Coulee. He is firing at an Indian who is shooting at him. This soldier could be Sergeant JamesButler, whose body was found quite a distance from the rest of Custer's command. According to Indian sources, including this and other drawings, a soldier with "stripes on his sleeves"[163] raced away from the Custer group, heading *south*. If this was Butler, he may have been acting as a messenger,[164] or simply trying to escape through a gap in the Indian perimeter. His mount was evidently a horse with good

---

[161]*Leavenworth Weekly Times*, "The Stories of Low Dog, Crow King, Hump, Iron Thunder."

[162]Interview with Sewell B. Weston, in Hardorff, *Lakota Recollections*, p. 189.

[163]Sandoz, *The Battle of the Little Bighorn*, p. 126.

[164]Greene, *Evidence and the Custer Enigma*, pp. 28–29.

bloodlines, and capable of great speed.[165] Butler's body was found not far from the river, near the mouth of Medicine Tail Coulee. There were many shells around his body, indicating that he had waged quite a battle of his own before he was killed. One native account reported that this soldier stood up firing, even though he was wounded, and held the Indians at bay for a long time. He was finally killed by a long-range bullet.[166] Butler may have been yet another in the long line of messengers sent back to Benteen to get him to hurry the ammunition forward. John Stands In Timber, however, states that many cartridge shells found in this location were due to the fact that the Custer battle actually began at this point.[167] [See discussion with Fig. 24.] Today, a lone marker points out the site where Butler's body was found.

Just above the river, to the left of Medicine Tail Coulee, are two dead Indian mounts, identified by the lack of saddles. The dead ponies may have belonged to warriors who crossed the river there to attack Custer's column as it approached or withdrew from the river. A few Cheyenne and Sioux did fire upon Custer's men from across the river, possibly slowing their advance, or turning them northward, giving other warriors time to join them at the river.[168] Light Indian resistance at that point in Medicine Tail Coulee could be taken as

---

[165]Kuhlman, *Legend into History, the Custer Mystery: An Analytical Study of the Battle of the Little Big Horn*, p. 231, and note 58, p. 167.

[166]Miller, *Custer's Fall*, p. 151; Stands in Timber and Liberty, ed., *Cheyenne Memories*, pp. 207-08. According to Stewart, Sgt. Butler's marker was moved in 1949 to a point farther back from the river, *Custer's Luck*, p. 444. This means that Butler may have died even closer to the river than his current marker would seem to indicate.

[167]Stands in Timber and Liberty, ed., *Cheyenne Memories*, p. 198.

[168]Powell, *People of the Sacred Mountain*, pp. 1020-21.

proof that Reno was successfully occupying the bulk of the warriors down at the southern end of the great camp.[169] John Stands in Timber said that it was hard work for the Indians to keep track of two different cavalry threats; a number of Indians went back and forth between the two,[170] though most of the Indians went to fight against Custer once Reno had reached the bluffs.

Custer's men left the river, headed in a northeasterly direction. Cheyenne accounts report that Cheyenne and Sioux warriors crossed the river at Medicine Tail Coulee to meet the soldiers.[171] Curley, one of Custer's Crow scouts, watched this part of the battle from a high hill with a good view of the battlefield. He said no Indians forded there until after Custer's men had turned away from the river.[172] Fox suggests the possibility that the Cheyenne tradition of an ambush attack on the soldiers at a fording place actually occurred farther north at what has become known as Ford D, a crossing down river from Medicine Tail Coulee, closer to the north end of the village, and the probable destination of those fleeing the great village.[173]

At the top left of Fig. 31,[174] riderless horses race off the field. Their riders, behind them on the ground, appear to be dead; the bodies are jumbled and superimposed upon each other. Two soldiers in lighter colored clothing may represent Custer or any of the other

---

[169]Fox, *Archaeology, History, and Custer's Last Battle*, p. 316.

[170]Stands in Timber and Liberty, ed., *Cheyenne Memories*, p. 200.

[171]Powell, *People of the Sacred Mountain*, p. 1020; Marquis, *Wooden Leg*, p. 229; Respects Nothing interview with Ricker, in Hardorff, *Lakota Recollections*, p. 31.

[172]Hammer, *Custer in '76*, p. 162.

[173]Fox, *Archaeology, History, and Custer's Last Battle*, p. 304.

[174]Photograph courtesy of West Point Museum Collections, United States Military Academy.

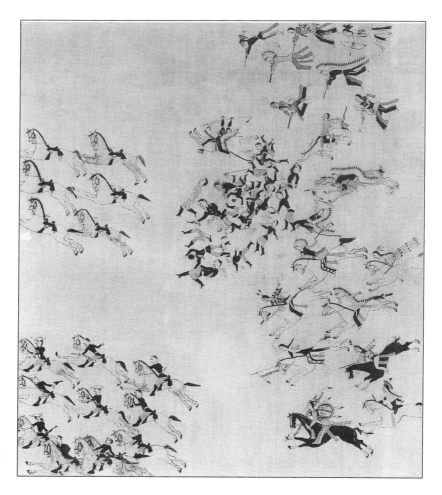

Figure 31

officers and civilians reportedly wearing buckskin or other clothing on the day of the battle.

At the top of the drawing, unmounted warriors approach the soldier position. The Indians who over-

whelmed Custer's group most likely did so on foot rather than by mounted charges. Few Indian casualties are visible in the drawing.

At the lower left, mounted soldiers flee from pursuing warriors. The sequence here is clear: the soldiers with Custer are dead, and the last survivors try to escape. This attempt was well documented by the Indians who fought Custer that day. Many Indians testified about a group of soldiers who tried to get away after everyone else was dead.[175] Some accounts tell of soldiers who ran away on foot, but this drawing shows mounted men fleeing the field. A bearded soldier, seen in the very lower left corner, may be the man who led the flight of these last men.

In this drawing, White Bird has carefully reproduced the details of the warriors' accouterments. A variety of headgear is seen, in addition to a shield with a long, feathered streamer, and a shield (lower right corner) with painted dragonfly designs. Above the figure with the dragonfly shield is a warrior wearing a cape with a painted owl motif.

White Bird employed a bird's-eye perspective of the entire battle. Most of the drawings by other artists concentrate on individual vignettes of the battle action, but White Bird neatly summarized the major focal points of the whole battle in a single work of art. The artist decided it was unnecessary to show every participant; the action could be quite adequately conveyed by the depiction of limited numbers of actors.

---

[175]Charles Eastman, in Graham, *The Custer Myth*, p. 97.

## Yellow Nose and Spotted Wolf

Spotted Wolf was the adoptive father of Yellow Nose, a Ute raised among the Cheyenne. Yellow Nose was a prominent participant in the battle of the Little Bighorn, and Spotted Wolf's ledger depicts some of Yellow Nose's exploits there. Located in the National Anthropological Archives at the Smithsonian Institution, the ledger book with 106 drawings in pencil, colored pencil, watercolors, and ink was collected between 1885 and 1889 by the Rev. H. R. Voth, an early ethnographer of the Cheyenne. The book was obtained from the Cheyenne Spotted Wolf on the Cheyenne Reservation in Darlington, Oklahoma.[176]

In Fig. 32, Yellow Nose has counted coup with a flag on two wounded soldiers, seen in the lower left section of the drawing, and is in the act of striking a third. Yellow Nose carries three captured carbines. A soldier, drawn superimposed upon a wounded cavalry horse, fires at close range at Yellow Nose. Other soldiers, signified by carbines visible along the right side of the drawing, fire at Yellow Nose. The bullets miss him, but his horse is wounded. One warrior described the action that day: "After we chased the soldiers back from the ford, [Yellow Nose] galloped out in front of us and got very close to the soldiers, then raced back to safety."[177]

Yellow Nose, Comes in Sight, Contrary Belly, and

---

[176]The Spotted Wolf drawings shown in this section as Figs. 32-35 are courtesy of the National Anthropological Archives, Smithsonian Institution, catalog number 166032. They are also illustrated in Powell, *People of the Sacred Mountain*. Other drawings from this ledger book appear in Powell, *Sweet Medicine*. The ledger drawings are approximately 7¼ x 12½ inches.

[177]Miller, "Echoes of the Little Bighorn," *American Heritage*, p. 34.

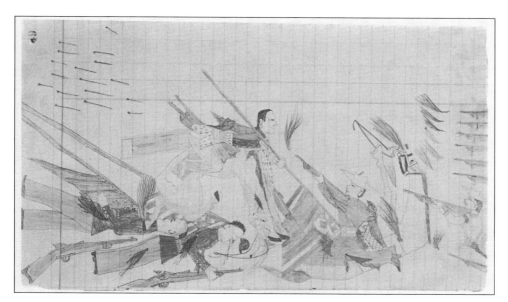

Figure 32

two others had charged in among Calhoun's soldiers, scattering their horses.[178] Turtle Rib later commented that he had observed that some soldiers on foot appeared to fight very coolly, while others were occupied with trying to control unruly horses.[179] The Indians had purposely targeted the horseholders,[180] a strategy which simultaneously demoralized the soldiers, diverted their attention away from their attackers, and trapped them on the battlefield without a means of escape. Moving Robe Woman, a Hunkpapa woman who took part in the Custer battle to avenge her brother's

[178]Powell, *People of the Sacred Mountain*, p. 1024.
[179]Hammer, *Custer in '76*, p. 210.
[180]Fox, *Archaeology, History, and Custer's Last Battle*, p. 189.

**115**

death,[181] saw the horseholders on Calhoun Hill trying to control eight to ten horses each. Moving Robe Woman said warriors waving blankets caused many of these held horses to bolt.[182] Horseholders customarily held only half that number, so her statement is an indication that even as early in the battle as this, there was an urgent need for as many men on the firing lines as possible.

Taking advantage of a lull in the firing while the horses were bolting in every direction, Yellow Nose had darted in among the soldiers and snatched a Seventh Cavalry Co. L flag from a trooper's hand. One observer described Yellow Nose's daring deed:

> Yellow Nose came riding in among them. One trooper was carrying a flag. As he saw Yellow Nose coming, he jumped on his horse and started to run. Yellow Nose was too quick for him ... [and] he grabbed the flag out of the trooper's hand ... [and] he charged ahead, striking soldiers right and left with the flag, counting coup on them, touching the soldier horses as well, claiming them as his own. ... He was a great man now, for he was first to charge in among these soldiers.[183]

Yellow Nose grabbed the flag from the man who was bleeding badly, and then the soldier fell off his horse.[184] These company standards were swallow-tailed American flags with gilt stars;[185] about fifteen such flags were captured in the battle, where they had been used to show the positions of the various companies.[186]

---

[181]Hardorff, *Lakota Recollections*, p. 93.
[182]Ibid., p. 95.
[183]Powell, *People of the Sacred Mountain*, p. 1024.
[184]Ibid., p. 1023.
[185]Ibid., p. 1024.
[186]Graham, *The Custer Myth*, p. xiii.

In the battle, observers remembered that Yellow Nose seemed to be everywhere at once. He carried the captured flag throughout the battle, counting coup on the soldiers.[187] He rode in and out among the troopers, counting coup many times, and never received a single wound.

When Custer's troops had approached the river, several Cheyenne reportedly began shooting across the river at them; the Cheyenne later reported that one soldier had been killed there. Then the troops had pulled away from the river while the Indians began crossing in pursuit. The soldiers had fallen back to a little knoll and halted there. Earlier, some of the troops had moved on across Medicine Tail Coulee and climbed the hill on the other side, moving toward the northeast.

Fox has composed a scenario, based upon archaeological evidence, which he feels explains the troop movements here: after separating from Custer's wing higher up in Medicine Tail Coulee, Calhoun's group, Cos. C, I, and L, headed for the positions where members of that group were later found dead; Custer, with the two companies, E and F, had ridden on down Medicine Tail Coulee toward the river, and then had turned sharply northward, leaving the ford area.[188] John S. Gray, however, feels instead that Custer accompanied the wing (consisting of three companies) which climbed up out of the coulee. While an argument can be made placing Custer with the group which rode toward the river, I agree with Gray that

---

[187]Ibid.; Miller, *Custer's Fall*, p. 131; Stands in Timber and Liberty, ed., *Cheyenne Memories*, p. 202.

[188]Fox, *Archaeology, History, and Custer's Last Battle*, p. 139.

Custer went with the group that crossed Medicine Tail
Coulee and deployed at various positions to the north.
If Custer sent Cos. E and F to the river to decoy war-
riors away from Reno and toward themselves, it was
certainly in character for Custer to have personally in-
volved himself with the deployment of the troops who
would take the brunt of the assault once the decoys
had lead the warriors back to the waiting soldiers. This
careful deployment was particularly necessary owing
to Benteen's continued absence from the field. Who
knew when or if Benteen would bring up the extra
men and ammunition? If it was Custer's intention to
carefully deploy what troops he had in anticipation of
the attack to come, the locations and attitudes of Cos.
C, I and L's dead show that he did not get all the time
he needed to make these deployments. The Indians
appeared too suddenly, and their numbers were such
that his deployments might not have mattered much
anyway.

In Fig. 32, one of the soldiers firing at Yellow Nose
is wearing a buckskin shirt. The hammer of the car-
bine at the bottom of the drawing is pulled back, pos-
sibly signifying that the soldier there did not fire at
Yellow Nose before the warrior killed him. This sol-
dier's carbine may have been rendered inoperable by
extractor failure.[189] Fox reports that he has found no
Cheyenne versions of extractor failure,[190] but the quote
below is from a Cheyenne. And if this drawing of the

---

[189]Sandoz, *Crazy Horse,* p. 326; Stewart, *Custer's Luck,* p. 421. When the expended
cartridges became jammed in the chamber due to a combination of heat and corrosion
on the shell, the extractor ripped the bottom off the cartridge instead of removing the
whole thing. The jammed cartridge had then to be removed with a knife, or the
weapon abandoned altogether.

[190]Fox, *Archaeology, History, and Custer's Last Battle,* p. 240.

unfired carbine *is* supposed to represent that particular kind of mechanical failure, then there are *two* Cheyenne versions of extractor failure at the battle of the Little Bighorn.

When interviewed after the battle, the Indians reported that Custer's men had had a great deal of trouble with malfunctioning weapons. Many carbines were jammed by empty shells stuck in the chambers. The Indians said many soldiers threw these weapons away and fought with the "little guns"—the pistols.[191] The Indians said many of the dead soldiers' carbines were found with shells stuck tight in the chambers, rendering them temporarily useless.[192] One warrior reported,

> I saw one rifle that had a shell of [a] cartridge in its barrel. A Sioux had it. He could not put into the gun any other cartridge, so he threw it into the river.[193]

In describing a carbine he had tried to take from an officer on Calhoun Hill, Red Feather, an Oglala Sioux, said, "The cartridges stuck in the gun because it was too smoked from shooting."[194]

This type of malfunction may have played a role in

---

[191]Gall, in Graham, *The Custer Myth,* p. 88; DuMont, *Custer Battle Guns,* p. 36. DuMont suggests that some members of the Seventh Cavalry discarded their carbines when they became inoperative, and fought with their pistols. Twenty-four rounds of ammunition per man gave very little sustained firepower for the five companies with Custer.

[192]Lt. Philo Clark, in Graham, *The Custer Myth,* p. 116.

[193]Marquis, *Wooden Leg,* p. 266. Many fouled carbines were deliberately thrown away by the Indians. Miller, *Custer's Fall,* p. 174. Reno complained to Brig. Gen. Stephen Benet, Chief of Ordinance, that the Springfield carbines, model 1873, used by some of his men had been rendered inoperative by extractor failure. DuMont, *Custer Battle Guns,* pp. 27, 29. During the Reno battle on the bluff, Capt. French sat in the center of the position where he worked to remove jammed shells from the chambers of the carbines. Brininstool, *A Trooper with Custer,* p. 37. Pocketknives with broken blades were found in the soldier positions during the 1984 archaeological survey, Scott and Fox, *Archaeological Insights into the Custer Battle,* p. 20.

[194]Interview with Scott, in Hardorff, *Lakota Recollections,* p. 85.

Custer's defeat, but probably not a major one. Extractor failure at the Custer battle is just one of many possible explanations proposed for the rapid deterioration of Custer's battle plan, and his subsequent defeat. Removal of jammed cartridge shells probably would have been a fairly easy task if one had had the leisure time to do it. But imagine the stress of using a pocketknife to pry a torn casing out of an overheated weapon, in the dust and noise and heat of the battlefield, knowing that while you worked, nothing stood between you and a horde of enemies.

According to Fox, there is no archaeological evidence that extractor failure was a significant factor in Custer's defeat; and, according to Fox, there is also no proof that Indian testimony concerning widespread extractor failure was not inflfluenced by white researchers and interviewers asking leading questions.[195] But Fox does not cite the studies in which questions of this sort were posed. Given the widespread collection of weapons by the Indians after the battle, perhaps the absence of cartridges and carbines showing signs of extractor problems is due to the fact that the Indians simply failed to leave much for Fox to find when he went over the battlefield more than a hundred years later. And it is likely that any weapons collected on the battlefield did not remain inoperable for long, for Sandoz[196] reported that, after the battle, a man named Good Hand, who was trained in gun repair at an agency blacksmith shop, was able to repair broken weapons and also get the jammed cartridges out of the carbines collected on the field.[197]

---

[195]Fox, *Archaeology, History, and Custer's Last Battle*, p. 243.

[196]Sandoz, *Crazy Horse*, p. 322.

[197]Ibid., pp. 322, 326, 330, 332; re cartridge defects discussed by records of the Dept. of the Platte, 1876, note p. 425.

It is possible that the soldier in this drawing simply ran out of ammunition. But some of the Indians reported finding large quantities of cartridges on the field; one warrior stated,

> These . . . soldiers discharged their guns but little. I took a gun and two belts off two dead soldiers; out of one belt two cartridges were gone, out of the other five.[198]

The fact that not much ammunition was expended indicates that the soldiers did not fire many shots, either because their positions were rapidly overrun, or because the weapons using those cartridges were discarded because of extractor failure, or because spare ammunition was carried away by runaway horses. When the soldiers' horses were stampeded, they carried with them the extra ammunition stored in the saddlebags. Wooden Leg reported finding two boxes of ammunition inside the saddlebags on a dead horse. He said, "Now I need not be so careful in expending ammunition."[199]

In Fig. 33,[200] Yellow Nose grapples with a buckskin-clad scout or soldier. The two of them fall to the ground. The white man is wounded in the head and ankle. Yellow Nose's horse has been wounded. The carbines fall to the ground. The flag has fallen to one side.

The bullets of the soldiers seemed powerless against Yellow Nose. His audacity that day seemed to have unnerved the soldiers further for some turned their backs on the Indians and raced off down the ridge toward the river. Soon the warriors were riding among

---

[198]Mallery, "Picture-Writing of the American Indians," p. 565.

[199]Marquis, *Wooden Leg,* p. 225.

[200]Spotted Wolf Ledger, NAA/SI; also illustrated in Powell, *People of the Sacred Mountain,* p. 975, and *Sweet Medicine,* p. 137.

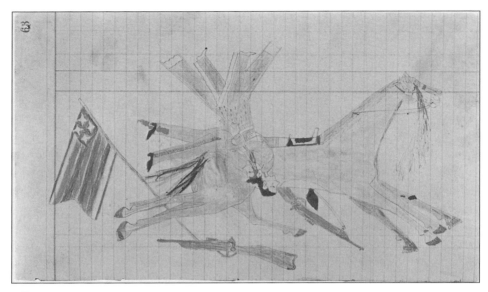

Figure 33

the troopers, striking them with their quirts or lances, counting coup many times.[201]

The Cheyenne hero of Fig. 34[202] is not specifically identified, but there are several indicators to show that the warrior is Yellow Nose. The yellow Indian pony, the flag, and the red leggings and blue shirt were seen in the two previous drawings of Yellow Nose and his horse.

On the left side of this drawing, the flag is being used to count coup on a soldier who is firing a carbine. The action continues to the right. The carbine has been knocked from the soldier's hands, possibly by the guidon, and is now on the ground in the bottom cen-

---

[201]Grinnell, in Powell, *People of the Sacred Mountain*, p. 1023.

[202]Spotted Wolf Ledger, NAA/SI; also illustrated in Powell, *Sweet Medicine*, p. 139.

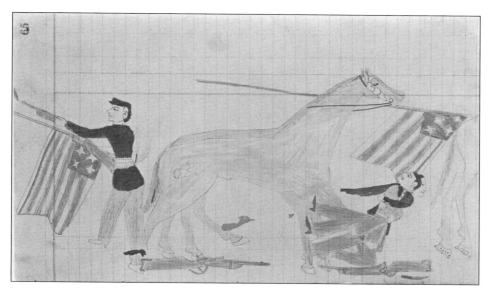

Figure 34

ter of the drawing. Farther to the right, the same soldier is now being thrown to the ground by Yellow Nose who, having counted coup on the now-unarmed soldier, wrestles with him. Yellow Nose probably succeeds in killing the soldier, possibly with the knife that is on the ground. Yellow Nose also counts coup on the man's horse, indicated by the flag touching the horse's rump.

In Fig. 35,[203] two Cheyenne warriors have charged a group of soldiers and Arikara scouts. Five discharging carbines at the right edge of the drawing mark the soldier positions; the two Arikara, identifiable by their

---

[203]Spotted Wolf Ledger, NAA/SI; also reproduced in Maurer, *Visions of the People,* p. 203.

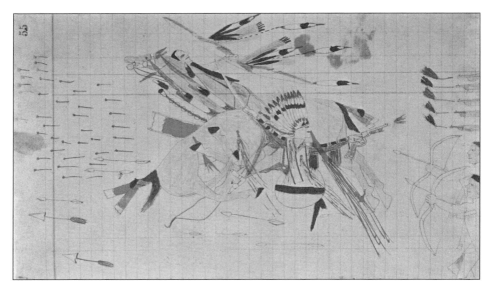

Figure 35

hairstyles which are different from the Crow style, are armed with bows. Numerous bullets and arrows fired by the soldiers and scouts go on off the left edge of the page.

The Cheyenne with the feathered headdress and painted shield has been wounded; his horse has probably been killed. The position of the horse indicates that it has fallen, pitching its rider over his head and probably falling on him. This Cheyenne is armed with a pistol, a carbine, and a saber. He is bleeding heavily from his mouth or nose, as well as from one or more chest wounds.

The other Cheyenne, who is probably not Yellow Nose, has a ring painted around his face, and is carrying a specially decorated military society bow; he is

racing away from the shooting, back to the safety of the Indian lines.

The presence of the Arikara scouts in this drawing indicates that the scene took place against Reno's command, as no Indian scouts, either Arikara or Crow, were with Custer's column while it was under attack. Sometime after separating from Reno, Custer had released the Crow scouts from duty, but Mitch Boyer, the Crows' interpreter, had remained with Custer. All the Arikara scouts were either with or in the vicinity of Reno's command.

Two brave Cheyenne men with painted shields and war bonnets with long eagle feather streamers have been thrown to the ground in another drawing from the Spotted Wolf Ledger, and not pictured here.[204] They have been severely wounded; both of their horses are probably dead. A line of nine carbines along the right edge of the ledger page indicates the cavalry position against which these two men charged.

On the basis of the tadpole designs on the leggings of the downed Cheyenne on the left of the scene, this warrior has been identified as Yellow Nose.[205] However, there is no documentation that Yellow Nose was wounded at the battle, or even unhorsed. And, in the other drawings made of Little Bighorn battle scenes, Yellow Nose's *red* leggings do not have the distinctive tadpole designs down the legs. Other drawings in this ledger book, however, show Yellow Nose in his tadpole leggings. The tadpole leggings probably serve as an identification device for another prominent warrior.

[204]Spotted Wolf Ledger, NAA/SI; also reproduced in Maurer, *Visions of the People*, p. 203.

[205]Maurer, *Visions of the People*, p. 205.

## White Bull

White Bull, also known as Joseph White Bull, was a Minneconjou Sioux warrior who participated in the battle of the Little Bighorn. He meticulously kept his war record in an old ledger book. In 1939, when White Bull was ninety years old, he showed author Stanley Vestal page after page of his personal military history which was illustrated by colored drawings.[206] His pictographs were made using a combination of ink, lead pencil, and crayon. White Bull's ledger is now found in the Orrin G. Libby Manuscript Collection of the Chester Fritz Library of the University of North Dakota.

White Bull had been taught to write in his own language after his surrender in 1876. Shortly after, he obtained a ledger book which he filled with his narration and lively, detailed drawings. In 1932, White Bull did other drawings for Vestal.[207] The location of these latter materials is not known.

White Bull's biggest claim to fame resulted from the uncertain distinction of (possibly) being the man who killed Custer, a position to which he was elevated by his biographer, Stanley Vestal.[208] After the battle, white interviewers repeatedly asked to know who had killed Custer. The answers ranged from no answer at all to the answer that a committee vote had conferred the honorary title on a likely candidate. What is most likely, however, is that whoever killed Custer did not recognize him at that time or later. Some of the Indians knew "Long Hair" was looking for them, but since

---

[206]Miller, "Echoes of the Little Bighorn," p. 35.
[207]Vestal, "The Man Who Killed Custer," p. 91.
[208]Howard, ed., *The Warrior Who Killed Custer*, p. v.

Custer's hair was cut short for this expedition, it is not likely that he was recognized in the excitement, dust, and smoke until after the battle. A few different soldiers, clad in buckskin outfits and riding light-colored horses, were later identified as Custer. Some soldiers, by virtue of the fact that they had died bravely or looked as if they were in command were also identified as Custer. Few Sioux really knew Custer by sight; he was much better known among the Cheyenne, some of whom did admit to recognizing his body on the battlefield.

In Fig. 36,[209] White Bull is armed with a carbine. He is wearing his *wotawe*, a small wooden hoop to which an eagle feather and tiny medicine pouches are tied on four sides.[210]

In the drawing, White Bull grabs the arm of a soldier, identified by White Bull as Custer himself, and causes the soldier's shot to fly wild. White Bull succeeds in throwing the soldier to the ground. According to White Bull,

> Long Hair [Custer] charged the camp and there was a lot of confusion and gunfire. Many Dakotas were killed as a result of this first charge and this made [us] mad. We counterattacked. We fought with them and I was in the first assault wave. . . . [Then] Long Hair came charging in but I pulled him off of his horse. He was lying at the east end.[211]

All of White Bull's drawings show the Custer figure clad in the clothing of a regular soldier. There is much information to show that Custer actually wore a buckskin suit into the battle, but according to Soldier, one

---

[209]Illustration courtesy of "Sioux History in Pictures by White Bull," OGL#183, Chester Fritz Library, University of North Dakota. See also Miller, "Echoes of the Little Bighorn." None of White Bull's drawings is illustrated therein, but Miller mentions them. The most comprehensive source of information on White Bull and his drawings is Howard, ed., *The Warrior Who Killed Custer*, which reproduces all the drawings.

[210]Ibid., p. 33.     [211]Ibid., p. 52.

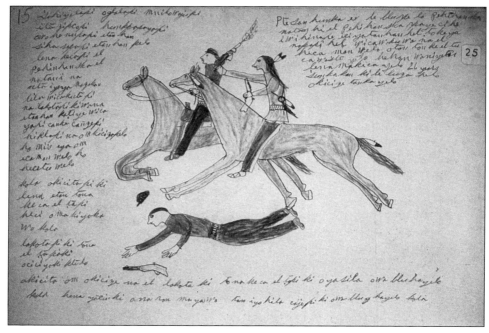

Figure 36

of Custer's Arikara scouts, Custer had taken off his jacket and tied it behind his saddle.[212] This means that Custer was probably wearing a blue shirt in the battle.[213] As many as eight other officers may have worn buckskin that day,[214] so buckskin cannot be considered a conclusive means of identification.

In Fig. 37,[215] White Bull faces a soldier who is firing at him with a carbine. The soldier also has a pistol in a holster shoved in the cartridge belt at his waist. The marks on the ground beneath the horse signify that

[212]Hammer, *Custer in '76*, p. 188, see note 3.
[213]Godfrey, in Graham, *The Custer Myth*, p. 345.
[214]Miller, "Echoes of the Little Bighorn," p. 29.
[215]"Sioux History in Pictures by White Bull," University of North Dakota.

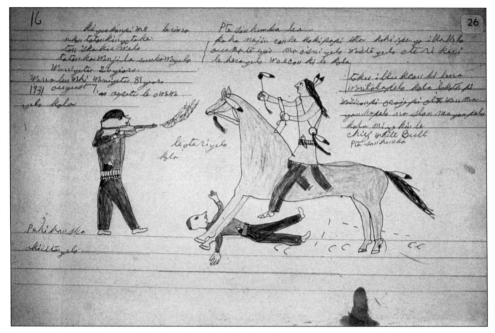

Figure 37

the same trooper was knocked down by White Bull's horse, which has a scalp hanging from its lower jaw.[216]

In this drawing, White Bull is armed with a carbine and a stone-headed war club, and has a knife in his belt. White Bull described the scene depicted here:

> This is Long Hair, the soldier. . . . He stood pointing his carbine at me and I was afraid but I charged him and ran him down. He fired at me but missed. It was lucky for me.[217]

In Fig. 38,[218] White Bull strikes the soldier,

---

[216]A scalp, or a horsetail painted red and black to simulate a scalp, was hung from a horse's bridle to show that this horse had been used to run down an enemy, Vestal, *Sitting Bull*, p. 27.

[217]Howard, ed., *The Warrior Who Killed Custer*, p. 54.

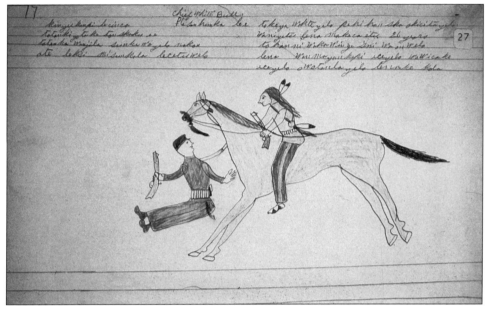

Figure 38

identified as Custer, with his quirt, and counts a coup. The soldier is shown sitting on the ground and may have been wounded in the thigh.

In Fig. 39,[219] White Bull wrestles with a soldier. The soldier falls to the ground; he appears to have a chest wound. The soldier's pistol is still is his belt. White Bull described this scene:

> I grabbed him and killed him. I counted first coup. He hit me with his fists and hurt me and then he grabbed my braids. I grabbed his carbine and killed him with it. I was scared but I finally succeeded. The soldier was Long Hair.[220]

White Bull said the soldier was strong and tried to

---

[218]"Sioux History in Pictures by White Bull," University of North Dakota.
[219]Ibid.
[220]Howard, ed., *The Warrior Who Killed Custer*, p. 54.

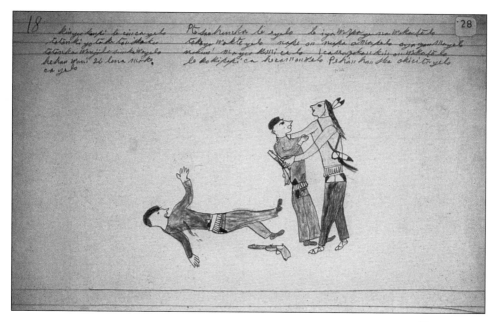

Figure 39

bite off his nose. White Bull called out for assistance, and some Sioux warriors identified as Crow Boy and Bear Lice, ran to help.[221] The soldier pounded on White Bull's head and shoulders with his fists. White Bull's helpers hit him instead of the soldier when they tried to help and White Bull told them to stay away. Finally he broke free and killed the soldier.[222]

In Fig. 40,[223] White Bull aims his carbine at a soldier holding two carbines, or one carbine and a pistol. The soldier, running away from White Bull, fires over his shoulder without taking aim. White Bull described the battle at this point:

---

[221]Miller, "Echoes of the Little Bighorn," p. 36; interview with Vestal, in Hardorff, *Lakota Recollections*, p. 116.

[222]Miller, *Custer's Fall*, pp. 147-48.

[223]"Sioux History in Pictures by White Bull," University of North Dakota.

**131**

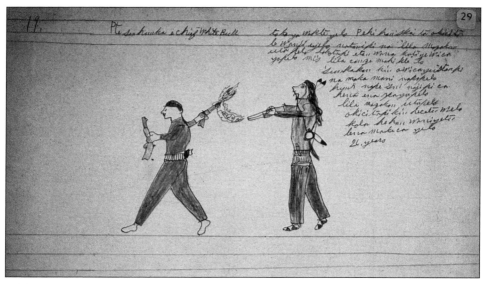

Figure 40

We charged [the soldiers] and the Dakotas were raked with a heavy fire. Many of us were killed by this volley. This made me very mad. [The soldiers] left their horses and fled on foot. Some did not retreat but stood their ground. We overran their position, although the soldiers kept up a heavy fire.[224]

One of the soldiers, finding himself surrounded by Indians, stood turning from side to side, threatening the Indians with his carbine. He did not dare fire for it would leave him defenseless. White Bull rode straight at the trooper and the man fired at him. White Bull dodged and the shot missed him. White Bull knocked the man down with his horse and rode over him.[225]

---

[224]DeBarthe and Stewart, ed., *Life and Adventures of Frank Grouard,* p. 58.
[225]Ibid.; Miller, *Custer's Fall,* p. 143.

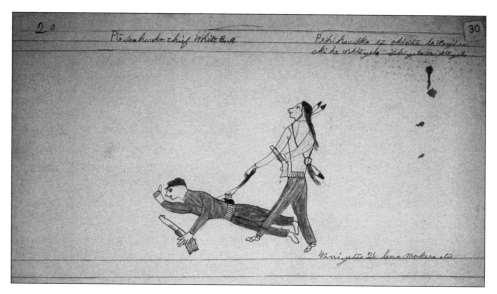

Figure 41

In Fig. 41,[226] White Bull used his quirt to count coup on a fallen trooper. After killing the soldier he identified as Custer, White Bull took cover in a ravine down the slope. Some of the soldiers on the ridge near the present-day monument seemed to think they would not be able to hold the position there much longer. Several of them jumped up and rushed down the ravine in front of White Bull, shooting all the while. White Bull described the scene:

> Ten of them jumped up and came down the ravine toward [us], shooting all the time. Two soldiers were in the lead, one of them wounded and bleeding from the mouth. [We] waited for them. When they came near, [I] shot one; the Cheyenne shot the other.... The eight remaining soldiers kept on coming, forcing [us] out of the ravine....

---

[226]"Sioux History in Pictures by White Bull," University of North Dakota.

**133**

White Bull got a dead soldier's gun and started up-hill, but was wounded in the ankle.[227] White Bull was hit by a spent bullet. He crawled into a gully and, after the battle, his friend With Horns found him and helped him back to camp.[228]

White Bull is shown in Fig. 42[229] counting coup on a soldier and taking his pistol. The horseshoe marks indicate that this soldier was in a group who fled on horseback. According to Howard, the soldier depicted in this drawing is a member of Calhoun's Co. C. White Bull claimed to have led the charge which seemed to break the morale of the survivors of Calhoun's company which then fled to join Keogh's I Co.[230] A few soldiers from Co. L had tried to break through the Indian lines to Co. I, but White Bull and others had charged across their line of flight and scattered them.[231]

In Fig. 43,[232] three soldiers fire at White Bull. The horseshoe marks in a half-circle pattern indicate that White Bull has ridden his horse right up to the enemy lines before reining in and turning around. Such feats of bravado were common in Plains Indian battles. White Bull is unhurt in this episode, but the horse has been wounded in several places.

Stanley Vestal published a slightly different drawing showing the killing of the soldier identified as Custer by White Bull. In Fig. 44,[233] White Bull strikes the

---

[227]Vestal, *Warpath*, p. 200; Howard, ed., *The Warrior Who Killed Custer*, pp. 58-59.

[228]Howard, ed., *The Warrior Who Killed Custer*, p. 57.

[229]"Sioux History in Pictures by White Bull," University of North Dakota.

[230]Howard, ed., *The Warrior Who Killed Custer*, p. 60.

[231]Miller, *Custer's Fall*, p. 139.

[232]"Sioux History in Pictures by White Bull," University of North Dakota.

[233]"Sioux History in Pictures by White Bull," University of North Dakota. Vestal, "The Man Who Killed Custer," p. 4.

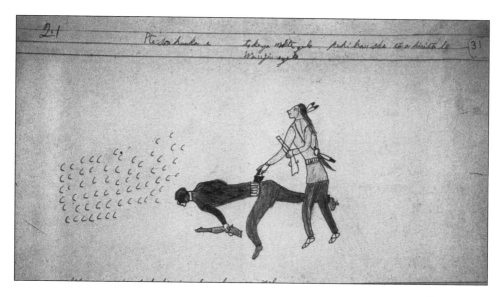

Figure 42

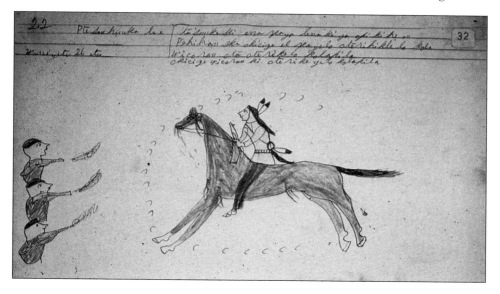

Figure 43

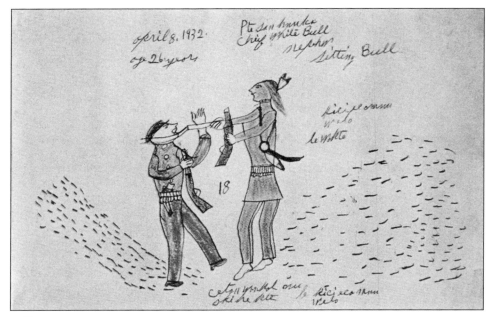

Figure 44

soldier across the face with his quirt. White Bull is armed with a carbine; the soldier also has a carbine, as well as a pistol in his belt. The marks on the ground probably represent the footprints left by the soldiers and their Indian pursuers.

When Vestal first interviewed White Bull, he was careful not to reveal the identity of the soldier White Bull killed in order to protect White Bull from possible reprisals.[234]

There is no information on the current location of the original of the drawing used by Vestal.

---

[234]Howard, ed., *The Warrior Who Killed Custer*, p. 52.

**136**

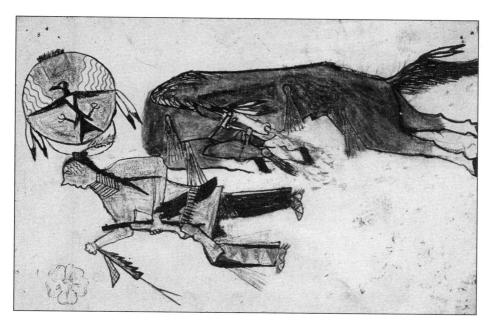

Figure 45

## No Two Horns

No Two Horns (1852-1942) was a Hunkpapa Sioux. Several of his drawings were collected by Rev. Aaron McGaffey Beede at Standing Rock Reservation in North Dakota.[235] No Two Horns was a cousin of Sitting Bull and participated in the battle of the Little Bighorn.[236]

---

[235]No Two Horns' drawings on pages of an art book were made between 1900–1915, and are currently in the collections of the State Historical Society of North Dakota, catalog #9380. Fig. 45 is reproduced here with their permission. There are forty-three items, including a large tipi cover; Maurer, *Visions of the People*, p. 209, reproduces some of No Two Horns' drawings.

[236]George Horse Capture, in Maurer, *Visions of the People*, p. 208.

Fig. 45 shows only No Two Horns, his painted shield and his dead war horse. No Two Horns made many drawings on paper and fabric for the tourist trade, and one of his favorite scenes seems to have been the killing of his horse.

In this drawing, No Two Horse wears a bone breast-plate, and carries a carbine and a carved, wooden quirt. He has a large sheath knife stuck in the cartridge belt about his waist. He wears beaded leggings, and beaded moccasins. His face is painted with wavy lines like the ones on his painted shield. His horse is painted with lightning designs; the horse must have received several wounds before it finally died, falling and breaking its neck and throwing No Two Horns to the ground.

Another No Two Horns piece,[237] not shown here, is a canvas tipi cover with his painted shield design at the top of the back, and many war scenes from No Two Horns' life. A drawing similar to Fig. 45 above, showing the death of the blue roan war horse, appears at the top right front of the tipi.

## Unknown Cheyenne

Anther drawing related to the Little Bighorn battle was made on a section of a hide tipi liner collected by James Mooney in Darlington, Oklahoma in 1904.[238]

---

[237]No Two Horns' tipi cover, formerly belonging to Mandan Indian Shriners, El Zagel Temple, Bismarck, North Dakota, now in the collections of the Minneapolis Institute of the Arts, personal communication from David Jensen, 6-18-96. Tipi cover pictured in Maurer, *Visions of the People*, p. 209.

[238]Unknown Cheyenne, Negative Number A107621, Field Museum of Natural History; commissioned and collected by James Mooney, Maurer, *Visions of the People*, p. 197.

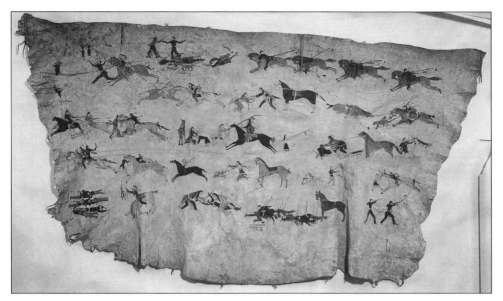

Figure 46

This piece, by an unknown artist, is painted with scenes of different battles between the Cheyenne, soldiers, and various enemy tribes and is not illustrated in this study. The drawings on this piece chronicle the events of an entire culture as well as the life of the individual who painted it.

The scenes in Fig. 46 are arranged in five rows, with the lower row devoted to Little Bighorn events. On the right end of the row, two solitary soldier figures fire at unseen enemies in an action that must have been mirrored by dozens of similar encounters between stand-up-and-fight white men and a people trained from birth to blend into and take cover from every natural feature, no matter how insignificant.

**139**

Farther to the left, a lone cavalry horse [Comanche?] stands by the heaped bodies of the soldier dead. The bows above them show that coups were counted on them as they fought and died. Below them are three carbines, an accounting of captured weapons.

Continuing to the left end of the row, the next vignette shows two Cheyenne warriors killing a trooper; or perhaps one is trying to scalp a soldier who was merely wounded or pretending to be dead.

At the left end of the row, a Cheyenne warrior wearing a war bonnet has charged up to a line of soldiers. The warrior's horse has been shot and is pitching its rider forward; the rider has been wounded in the hand.

## One Bull

One Bull, a Hunkpapa Sioux, belonged to Sitting Bull's band and was a participant at the battle of the Little Bighorn. Fig. 47,[239] a painting on muslin, is entitled, "Custer's War." This title and several captions in both English and Lakota have been written on the painting. At the bottom are the names of the artist One Bull, and witnesses Gall and Sitting Bull. The identity of the person who wrote the captions is unknown. This piece was collected at the Standing Rock Reservation in North Dakota.

---

[239]Painted ca. 1900; formerly belonged to Mandan Indian Shriners, El Zagel Temple, Bismarck, North Dakota, transferred to the Minneapolis Institute of the Arts, personal communication from David Jensen, 6-18-96. Used here with the permission of the Minneapolis Institute of Arts. Pictured in Maurer, *Visions of the People*, p. 198.

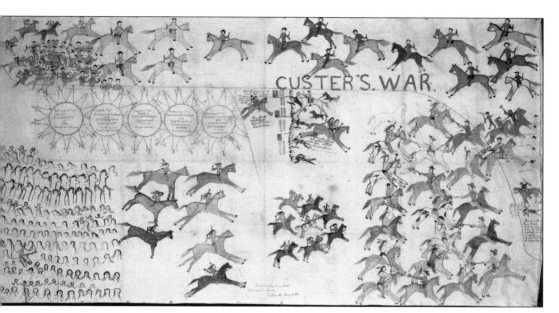

Figure 47

Five circular elements in the left half are depictions
of the various camps pitched in circles on the west side
of the Little Bighorn in June of 1876. Above the circles
is a line representing the river.[240] To the immediate
right of the camp circles is a line which represents the
ravine which separated Reno's men from the tipis on
the southern end of the line of camps, and from
which, Reno said, masses of warriors had appeared be-
fore him.

Farther right are Reno's three companies, each with
its own guidon, and Reno's dismounted skirmish line

[240]Standing Bear lists the camps at the Little Bighorn, from south to north, as
Hunkpapa, Oglala, Minneconjou, Sans Arc/ Two Kettle, Cheyenne, and Santee. Some
authors list five camps, and others give six. Demallie,ed. *The Sixth Grandfather*, p. 180.

marked by riderless horses being held, and men stretched out on the ground along the line. This painting is another in the bird's-eye-view category in which entire before, after, and during sequences of events are "simultaneously" depicted.

In a 1919 interview, Red Feather, an Oglala Sioux, said he charged the Reno soldiers "where flags were planted";[241] as the Indians raced toward the cavalry line, the flags were pulled up, and the retreat was on. The dead warrior on the skirmish line could be Hawk Man who was reportedly killed there.[242]

In the lower part of the right half of the painting, mounted warriors and soldiers mixed up together race away from the village. Some war horses are painted with individual designs, such as dragonflies and birds, identifying to knowledgeable contemporaries the warrior-riders in that confusing mass of men.

Behind these riders, latecomers hurry up from the villages. Reno's interlude in the timber is not shown, supporting my contention that Reno's stay there was seen by the Indians as a pause so slight it might never have occurred at all.

The unadorned human torsos outlined in a squarish mass in the lower left corner may be an accounting of warriors wounded or killed in battle.

At the far right, Reno's men recross the river, while others already up on the bluff provide some sheltering cover. No other artists have shown this aspect of Reno's river crossing.

Across the top of the painting, appearing from the right side, are new soldiers. These are Custer's men,

---

[241]Interview with Scott, in Hardorff, *Lakota Recollections*, pp. 82-83.

[242]Hardorff, *Lakota Recollections*, note p. 93.

riding northward along and behind the line of bluffs rising from the eastern side of the river.

At top center, Custer's north-riding men encounter riders—not new or different ones, I believe, but themselves in retreat, in a kind of artistic blend of a prophecy of things to come, and things which have already happened.

In the top left center of the drawing is a circular element of mixed-up heads and hats, torsos and weapons, so closely surrounded by warriors that all movement seems crushed and frozen forever, as indeed it was. Any of Custer's men who tried to escape on horseback didn't get very far.

Another version of these scenes by One Bull is in the collections of the Sioux Indian Museum in Rapid City, South Dakota.[243] I have not had the opportunity to see this piece; no photo was available due to extensive museum remodelling.

## Standing Bear

Standing Bear was a Minneconjou Sioux whose family chose to live with the Oglala people who followed Crazy Horse. In 1876, Standing Bear was seventeen, and old enough to participate in the battle on the Little Bighorn.[244] A quarter of a century later, Standing Bear made graphic records of the fighting and dying that he and others had seen that day. The practice of making such drawings with a sort of commit-

---

[243]Maurer, *Visions of the People*, p. 198.
[244]DeMallie,ed., *The Sixth Grandfather*, pp. 101, 173-74, 184-90.

tee-style collaboration helped ensure that an artist's
version of events was corroborated, strengthened, and
refined by the recollections of others who had partici-
pated in the same events. It is unfortunate that the
current owner of this piece refused to allow illustra-
tions of this drawing to be published. Standing Bear's
painting is of singular relevance to the battle of the
Little Bighorn.

This drawing,[245] not shown here, was painted on
muslin, and was probably used as a tipi liner. There is a
possibility that Standing Bear was commissioned to
create two additional related paintings on muslin at
about the same time, between 1889 and 1903.[246]

The time frame of this large muslin drawing by
Standing Bear spans the weeks before the Custer bat-
tle, and the battle itself. The multitude of events por-
trayed there include day-to-day occurrences such as
courtship and camp scenes, and special ritual obser-
vances.[247] One author has said,

> This painting of the events leading up to and including the
> Battle of the Little Bighorn is one of the most elaborate
> and visually complex historical narratives in Plains art....
> Despite the number of figures and objects, the artist main-
> tained a sense of visual clarity and readability that allows us
> to follow the narrative even though the painting connects
> events that took place over several weeks.[248]

In 1907, Standing Bear made a map of the Custer
battlefield for Eli S. Ricker.[249] His drawings, corre-
spond well with the physical features shown there.

---

[245]Owned by Foundation for the Preservation of American Indian Arts, Inc., Chicago.

[246]Powell, in Maurer, *Visions of the People*, p. 82. Reproduced in Maurer, p. 162.

[247]See Maurer, pp 84-101, for highly detailed descriptions of the ceremonies and rit-
ual paraphernalia depicted in Standing Bear's painting.

[248]Ibid., p. 199.

[249]Interview with Ricker, in Hardorff, *Lakota Recollections*, p. 58.

Standing Bear's painting of this final Custer battle portrays the last stages of the action, shown in the upper half of the drawing, above [east] of a parallel set of lines representing the Little Bighorn river.

On the right side, immediately below the river, are three of the camp circles which had been set up several days earlier. Within, below, and to the left of the camp circles are running women, some with babies on their backs, leading horses and driving others before them. Women and men carrying rawhide ropes race to catch horses. Powell[250] identifies the white-painted figure running with the women as a Sioux *heyoka*, a man who dreamed of thunder, a vision which bestowed great power, and was thereby ordained for a kind of backwards-frontwards life of specific contrary behaviors.[251]

Farther to the left are two riders, and past them, more loose horses and a couple of women leading pack horses, one pulling a travois with a wicker cage designed to keep babies and puppies from rolling off onto the trail. Black Elk said that when his family left the Little Bighorn, he and two younger brothers had to travel in a travois, along with a bunch of puppies. Black Elk was charged with keeping the puppies in the cage.[252] In the drawing, a dog with a small travois follows behind.

The women and the mounted couple are part of the pre-Little Bighorn part of the drawing, as the well-dressed, courting couple is far more casual than the situation warrants. And, by most accounts, the non-combatants fled toward the north end of the camps and beyond to a safe place from which to watch the battle. The tipis were left standing and belongings

---

[250]Maurer, *Visions of the People*, p. 101.
[251]DeMallie,ed., *The Sixth Grandfather*, note p. 105.
[252]Ibid., p. 196.

temporarily abandoned in the rush to get out of the way of the soldiers' bullets.

Above (east) of the river, a fierce battle is being waged. In the upper right corner, four hatless and mounted soldiers, three looking back at the battle they have left behind, are racing to the right, or southward. At least one of their horses is wounded, and one of the soldiers has an arrow in his back. The soldiers are pursued by a warrior wearing a split-horn headdress, and who reaches out to count coup on one of the soldiers with his bare hand, an act of incredible bravery.

Below the soldiers are four mounted warriors racing along in the same direction, possibly to head off the escape of these enemies. Across the top of the drawing is a line of standing soldiers with guidons flying overhead, an indication that these men, forced to gather together, include men from different companies who gravitated toward Custer. None of the white men is wearing buckskins, so no one here can be identified as Custer.

The white men's arms are extended to the left, in the direction of a stampeding bunch of cavalry horses, perhaps just released in an effort to buy time by luring warriors away from their front—an ultimately futile gesture as expected reinforcements did not appear, and because the number of warriors was just too great. White Bull described this last part of the battle:

> Then for a time all the soldiers stood together on the hill where the monument is now, ringed in by the Sioux, dying bravely one by one as the Indians poured a hail of lead and arrows into their dwindling strength. They lay or knelt on the bare ridge, firing across the bodies of dead horses or taking cover behind the shallow shelter of a fallen comrade. . . .[253]

---

[253]Vestal, *Warpath*, p. 199.

**146**

Below the line of standing soldiers are dead and dying soldiers and horses. Company guidons are scattered around nearby. A warrior in a headdress and a feathered lance manages to hang onto his rearing war horse while at the same time shooting at a bearded soldier. All around, other warriors count coup, and chase and ride down soldiers, or let loose arrows into the air to rain down on the unprotected troopers on the ridge. Nearby, a warrior wearing a headdress yanks a guidon from the hands of a soldier; the warrior is probably Yellow Nose.[254] John Stands in Timber stated that, toward the end of the battle, Yellow Nose had grabbed an American flag that was held upright by a clump of sagebrush, and had ridden into battle with it, using the flag to count coup on one of Custer's soldiers.[255] Thematically, the drawings in the study showing Yellow Nose with flags or guidons vary somewhat from each other; it is possible, considering the bunching of flags especially near the end of the Custer battle, that Yellow Nose was involved with more than one instance of taking a flag, or counting coup with a flag, or fighting soldiers with flags. In Standing Bear's drawing, Yellow Nose is not dressed as he was pictured in some of the drawings in the Yellow Nose/Spotted Wolf ledger.

In a rough vertical line in the left center of the drawing, a group of soldiers is running west toward a ravine which runs all the way to the river. The ravine is shown as a rectangular smudge full of soldier heads and the half-bodies of a soldier and a warrior. Showing partial

---

[253]Vestal, *Warpath*, p. 199.

[254]Henry Little Coyote, Frank Waters, and John Stands in Timber, sons and grandsons of Cheyenne men who had fought against Custer, identified this warrior as Yellow Nose, Powell, in Maurer, *Visions of the People*, p. 98.

[255]Stands in Timber and Liberty, ed., *Cheyenne Memories*, p. 202.

**147**

bodies is a device used to show an obstruction to the line of sight, the banks of the deep ravine, in this case.

Some of the soldiers have been killed during the run downhill. A soldier, shown just above the ravine, has been ridden down by a mounted warrior. A handful of survivors has managed to reach the illusion of safety in the ravine.

White Bull and a Cheyenne warrior had been in this ravine, firing from under cover at the soldiers on the ridge. When everyone up there had seemed dead, a group of about ten soldiers, the last ones left alive, made a dash for the river and the cover offered by this ravine. They were shot at by White Bull and his companion, but the soldiers took possession of the ravine, routing the two warriors.[256] White Bull was wounded shortly thereafter, and spent the rest of the fight lying in a shallow gully.

Respects Nothing, an Oglala Sioux, later stated that one Indian had been killed at the ravine, a Cheyenne warrior named Noisy Walking, son of the famous Cheyenne holy man, Ice.[257]

To the right of the ravine, a mounted warrior with a saber charges toward the soldiers who have forced White Bull from his position there.

The most prominent figure on the field appears to the left of the ravine. This warrior and his war horse calmly approach the action from the north side of the field. His dress identified him as a man of some prominence, perhaps Crazy Horse, but the man is not

[256]Vestal, *Warpath,* p. 200.

[257]Marquis, *Wooden Leg,* p. 241. John Stands in Timber lists Noisy Walking as one of the "suicide boys," who died near the site of the present-day monument. Stands in Timber and Liberty, ed., *Cheyenne Memories,* p. 194. This location is somewhat compatible with Respects Nothing's comment that this warrior died "at the ravine."

dressed as other reports indicate Crazy Horse was on that day.[258] Powell identifies this individual in the scalp shirt as the Cheyenne Lame White Man; in 1959, Rufus Wallowing, a Northern Cheyenne, also identified this prominent figure as Lame White Man.[259] However, John Stands in Timber, Lame White Man's grandson, stated that his grandfather went into battle against Custer's column wearing only a breechclout, having come to the fight straight from a sweat bath.[260] Lame White Man was not in the battle very long and was killed and scalped accidentally by Sioux warriors precisely because he was *not* dressed distinctively. Lame White Man had been mistaken for an enemy Arikara scout; they frequently fought stripped down for battle.[261]

Another Standing Bear painting on muslin is found in the collections of the Philbrook Museum of Art, in Tulsa, Oklahoma. In Fig. 48,[262] the camps are shown here as six separate arcs rather than circles. The main focus of this piece is the events of the Custer battle east of the river. The Reno battles are not portrayed here, and Standing Bear has not included the information on Sioux life and culture, or the events of the days leading up to the battle of the Little Bighorn, as he did in the drawing discussed previously.

Standing Bear's depiction of the camps includes the

---

[258]See Bad Heart Bull's drawings, for instance.

[259]Powell, in Maurer, *Visions of the People,* p. 99.

[260]Stands in Timber and Liberty, ed., *Cheyenne Memories,* p. 203.

[261]Ibid., and DeMallie, ed., *The Sixth Grandfather,* p. 186.

[262]Standing Bear painting on muslin, using pencil and watercolor; this piece measures 35 x 174 inches. The image is reproduced by permission of The Philbrook Museum of Art, Tulsa, Oklahoma. An illustration of this piece was reproduced in Byrnes, *The Artist as Collector: Selections from Four California Collections of the Arts of Africa, Oceania, the Amerindians and the Santeros of New Mexico,* 1975.

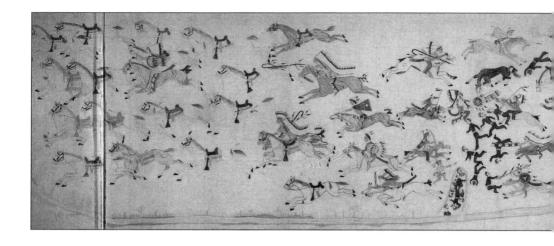

fleeing women and children, as well as the *heyoka*. The refugees follow a trail of horse tracks leading north out of the villages and toward the shelter of a ravine beyond.

That the piece was done by the same artist who made the previous drawing, and that it concerns the same battle, is very obvious. The differences between the two pieces are minor. In Fig. 48, Medicine Tail Coulee has not been sketched in; at the upper right, three mounted soldiers race off the field instead of the four seen in the first Standing Bear piece. A single dead officer lies near the eastern bank of the river just across from the camps in Fig. 48. More dead cavalry horses than shown in the previous drawing dot the landscape of the "last stand" area. Many different warriors, identifiable by their accouterments, are present on the field in Fig. 48, and on the north, above and to the right of the headquarters grouping in this illustra-

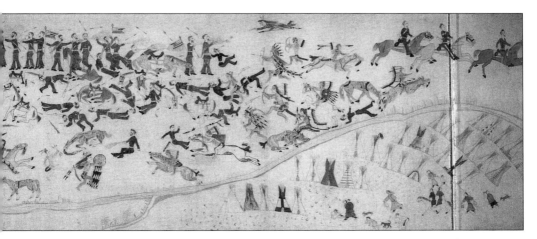

Figure 48

tion, a single warrior with a lance and a pistol crawls up, unnoticed, behind the soldiers occupied with warriors attacking from the south and west.

Considering the number of Sioux and Cheyenne warriors who took part in the battle, this painting seems to represent an effort by Standing Bear to record the presence and deeds of many specific warriors. I can find no exact duplicates of any of the individualized warriors in these two paintings by Standing Bear.

In 1931, Standing Bear was asked to make drawings to illustrate *Black Elk Speaks*, John G. Neihardt's biography of that Sioux holy man.[263] Standing Bear's drawings there are depictions of some of the actions which occurred in 1876 on the Little Bighorn battlefield, events participated in and witnessed by both Standing Bear and Black Elk, who was a boy at

---

[263]DeMallie, ed., *The Sixth Grandfather*, pp. 29-30, 95, 99, note 180.

the time of the battle of the Little Bighorn. He said he attempted to join the fight against Reno, but could not get through the throng of warriors surrounding the soldiers. He later rode over the Custer battlefield, looking at the bodies of the dead soldiers.[264]

When Custer and his men eventually reached the "last stand" site, Custer and the soldiers dismounted. Standing Bear said, "They were ready for us and were shooting. Our people were all around the hill on every side by this time." The soldiers who had dismounted to fire did very poor shooting. At first, they held the reins on one arm while firing, but the frightened horses pulled the soldiers all around. A great many shots went wild and harmed no one.[265] Then the horses broke loose and Custer's men were left afoot.[266] Near the end of the shooting, a group of soldiers jumped up and ran downhill toward the river.[267]

Fig. 49[268] shows a group of soldiers running away from mounted warriors. The soldiers are under fire from all sides. The soldiers are shooting as they run, but they are shooting wildly without taking aim. The long-haired soldier in the lead wears a buckskin jacket.

After the battle, one Indian source testified about a group of soldiers who had started running downhill toward the river. They fired their carbines and pistols in the air and made meaningless arm motions. The Indians fell back from the soldiers at first, then recovered

---

[264]Black Elk's story of the Little Bighorn appears in Neihardt, *Black Elk Speaks*, pp. 105-15, 129-34.

[265]Utley, *Custer Battlefield National Monument*, p. 50.

[266]Neihardt, *Black Elk Speaks*, pp. 117-18.

[267]DeMallie, ed., *The Sixth Grandfather*, p. 186.

[268]Figs. 49 and 50 appear on pp. III and 123 respectively, in Neihardt, *Black Elk Speaks*. The present location of these drawings is not known to the author.

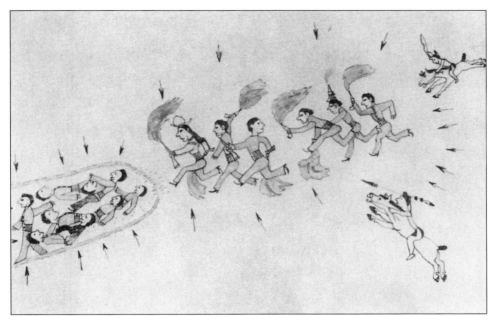

Figure 49

and charged.[269] According to Iron Hawk, Custer's men shot like drunken men, shooting into the ground, into the air, shooting wildly in every direction.[270]

On the left of the drawing, a group of soldiers, or perhaps the same group as the one running, lies dead. The circle around the dead soldiers represents fortifications of some kind, such as earthen breastworks, or a natural terrain feature such as a hollow, ridge, or ravine. There are footprints going into the ravine, but none coming out again, for everyone is dead. According to Standing Bear, the men in the

---

[269]Miller, *Custer's Fall,* p. 136.
[270]Interview with Ricker, in Hardorff, *Lakota Recollections,* p. 66.

ravine were killed by warriors using arrows, war clubs, and guns. He said the ravine was full of tall grass. The Indians lined the banks above the soldiers so there was no use in hiding there, for all the soldiers were easily seen from above.[271]

In Fig. 50, Custer's dead lie face down in the dirt near their dead horses. The soldiers have succumbed to the superior firepower of the surrounding Indians. Custer's battle flags lay on the ground.

After the battle, Lieutenant De Rudio of Reno's command reported that Custer's body rested on top of a conical knoll. There were several dead horses there, as if shot for a barricade. He said that all the horses were sorrels from Co. C, and that none of the dead men there had been scalped.[272] Another officer expressed the opinion that Custer's position showed greater care in deployment than was shown elsewhere on the field.[273]

In the drawing, no soldier weapons are visible; most would have been collected by Indians as soon as any position was overrun. The funnel-shaped marks around the soldiers' perimeter may indicate that the soldiers made a strong defense, firing as best they could at warriors who showed themselves as little as possible. In the Custer battle, the Indians had relied mainly upon bows and arrows. Thousands of arrows were found on the Custer battlefield—in the ground, in the soldiers, in the horses. The Indians were able to lob arrows into the soldier positions while remaining

---

[271]DeMallie, ed., *The Sixth Grandfather*, pp. 186-87; Hardorff, *Lakota Recollections*, p. 60.

[272]Quoted in Hammer, *Custer in '76*, p. 87.

[273]Lt. McClernand, in Stewart, *Custer's Luck*, p. 454.

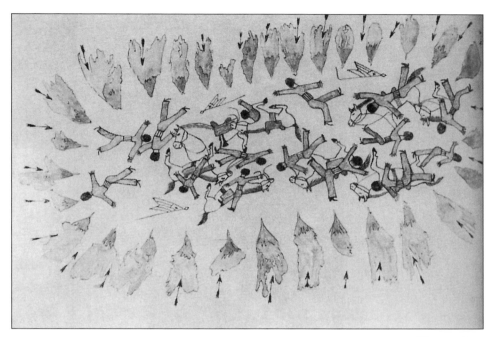

Figure 50

concealed, and the arrows which rained down upon Custer's men were deadly.[274] Early in the battle, some warriors lacking firearms or ammunition used bows and arrows. But as soldier positions were overrun, more firearms fell into Indian hands, to be turned against surviving soldiers. Arrows were not much used against the Reno and Benteen position on the bluffs because by then the Indians were armed with Custer's weapons and ammunition.

---

[274]Utley, *Custer and the Great Controversy*, p. 103; Gall, in Graham, *The Custer Myth*, p. 88.

## Little Big Man

Little Big Man was an Oglala Sioux, and at the time of the battle of the Little Bighorn, a close friend of Crazy Horse. Little Big Man participated in the Reno and Custer actions.

Little Big Man's drawing representing the Little Bighorn battle was supposedly commissioned by a Miss Sickels, a woman who may have been a teacher on a Sioux reservation. The drawing appears in W. Fletcher Johnson's book, *The Red Record: Life of Sitting Bull and History of the Indian War of 1890–'91.* Johnson wrote,

> Making due allowance for their inordinate love of praise . . . it is probable that the idea of the sketch is not exaggerated and that [Little Big Man] rushed into the fight wherever the fray was thickest.[275]

The current location of Little Big Man's drawing is unknown.

In Fig. 51, Little Big Man is indeed in the "thick of the fray"; he is the only Indian in a crowd of dead and dying soldiers. Clouds of arrows have rained down on the soldiers and their horses. Little Big Man's drawing bears out other Indian testimony that arrows were highly effective weapons against Custer's men.

Little Big Man, wearing a buckskin shirt trimmed with scalps or ermine tails, is shown counting coup on a bearded, flag-carrying soldier who has been shot in the back with an arrow. Some of the other soldiers may have chevrons on their sleeves. There are four battle flags visible in the drawing. A flag carrier usu-

---

[275]Johnson, *The Red Record of the Sioux,* p. 114.

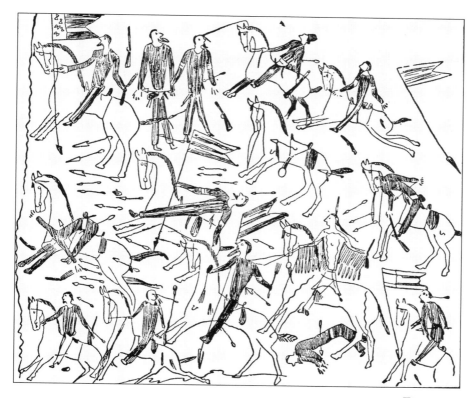

Figure 51

ally rode with the commanding officer of each company. A scene such as this, showing an aggregation of flags, may be merely the artist's condensing of an action, or an indication that Little Big Man fought against the so-called headquarters group of company commanders that seem to have assembled around Custer near the end of the battle.

Little Big Man's horse is painted with lightning stripes, and a scalp hangs from its lower jaw.

## Kicking Bear

The Sioux warrior Kicking Bear fought in the valley against Reno's soldiers, and was present when the last of Custer's men was killed. In 1890, Kicking Bear rose to prominence as an important leader in the Sioux Ghost Dance movement. In later years, he was sought out by journalists who wanted to interview him about the Ghost Dance, and about the battle of the Little Bighorn in which he had participated as a young man.

About 1898, artist Frederic Remington asked Kicking Bear to paint a picture of the Little Bighorn battle.[276] Kicking Bear's painting on muslin is found today at the Southwest Museum in the Highland Park area of Los Angeles, California.

Kicking Bear's drawing, Fig. 52,[277] is a pictographic roster of Little Bighorn battle participants and casualties. In the center of Kicking Bear's drawing is a group of four warriors, identified from left to right in the drawing as Sitting Bull, Rain in the Face, Crazy Horse, and the artist Kicking Bear. The handwritten names above some of the drawing's figures were probably not placed there by Kicking Bear, and I believe that two of them at least are in error; Crazy Horse should be second from the left, and Rain in the Face, the second from the right. In battle, Crazy Horse often wore a red-backed hawk on his head and was very plainly dressed.[278] Rain in the Face, on the other

---

[276]Stands in Timber and Liberty, ed., "Last Ghastly Moments at the Little Bighorn," *American Heritage*, p. 17.

[277]The drawing is reproduced courtesy of the Southwest Museum, Los Angeles, image CT. 1. Kicking Bird's drawing has been reproduced in ibid., and Tillett, *Wind on the Buffalo Grass.*

[278]Sandoz, *Crazy Horse*, p. 326.

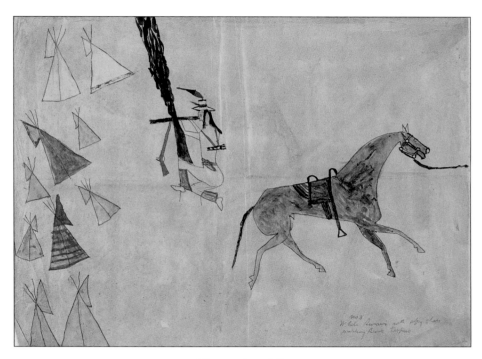

Figures 1 and 2.
See discussion on page 42.

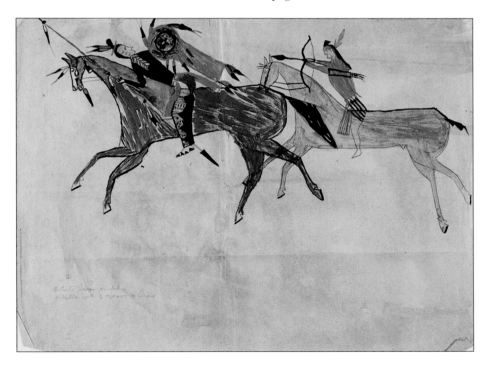

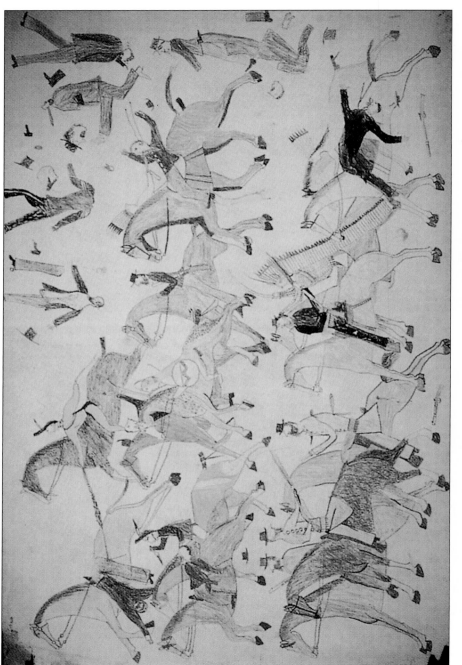

Figure 26. See discussion on pages 86–87.

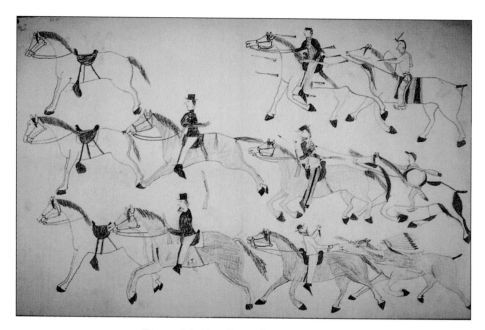

Figure 28. See discussion on page 89.

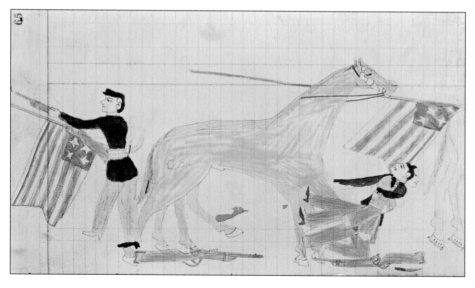

Figure 34. See discussion on pages 122–123.

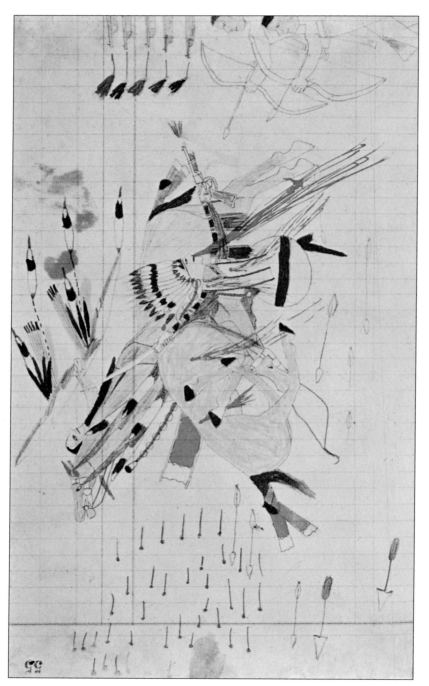

Figure 35. See discussion on pages 123–125.

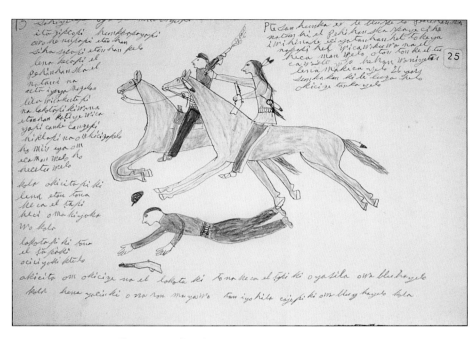

Figure 36. See discussion on pages 127–128.

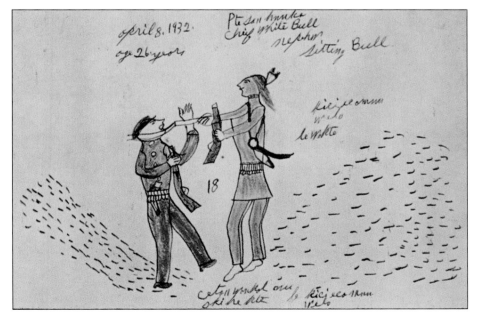

Figure 44. See discussion on pages 134–136.

DECORATION.—Ideal Leaf or Flower Form.—Color.

Figure 45. See discussion on page 138.

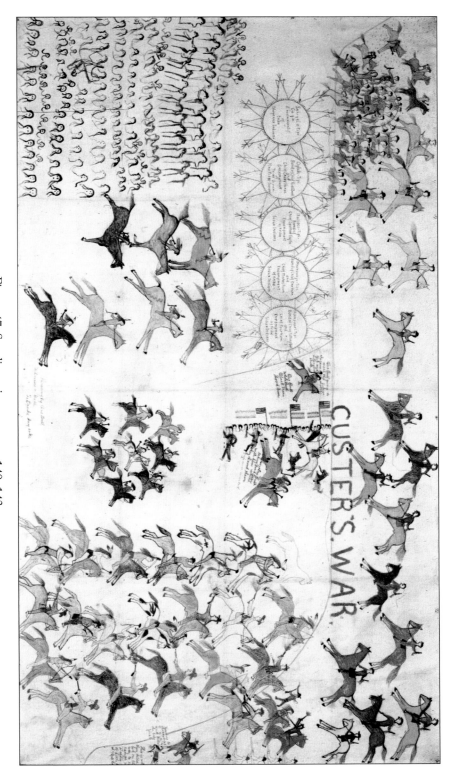

Figure 47. See discussion on pages 140–143.

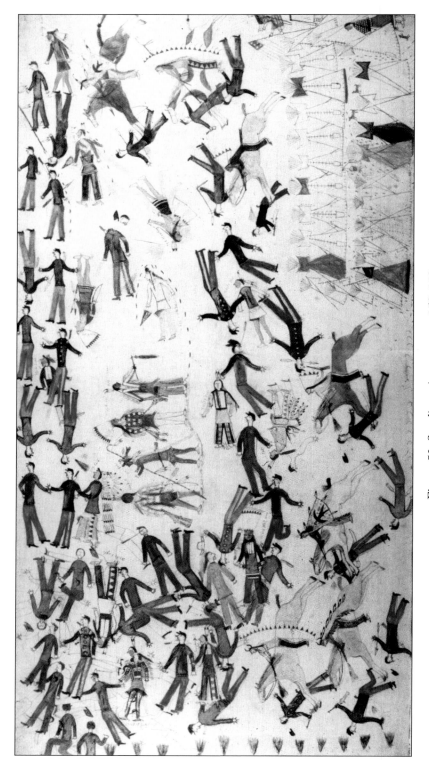

Figure 52. See discussion on pages 158–160.

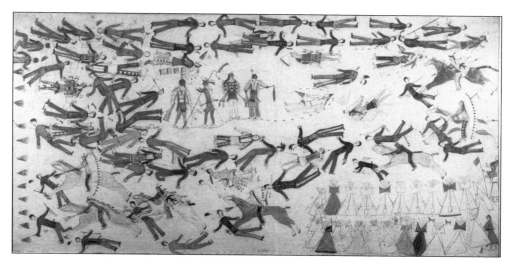

Figure 52

hand, is frequently seen in old photographs wearing a stand-up war bonnet. Crazy Horse reportedly never cared to wear such ostentatious things.

Sitting Bull displays his captured weapons; Crazy Horse is wearing his red-backed hawk and holding his coup stick; Rain in the Face is wearing his stand-up war bonnet and is holding captured soldier guns; and Kicking Bear is holding a scalp on a stick, and captured guns.

To the right of Kicking Bear is an unidentified dead Crow scout with an umbrella, popular trade items on the Plains. [See p. 41 for a description of the Crow scout White Swan being carried off the field.] The field is covered with soldier and Indian casualties. Some of the dead Indians are identified by name. The long-haired figure of Custer, dressed in very yellow buckskins, is found to the left and below the figure

identified as Sitting Bull. Even though Custer's hair was cut short for the 1876 expedition, his long hair here functions as an identification tool since he was known to the Plains Indians as "Long Hair."

At the lower right corner is the Sioux village, complete with painted tipis, dogs, and cooking kettle. Women holding American flags watch the battle from afar.

Some of the dead soldiers have been stripped. Others, still wearing their uniforms, are easily identified as officers and enlisted men. The dead soldiers are almost anonymous, but the dead Indians are unique in terms of their dress and ornamentation. Indians looking at pictographic drawings of the battle years later would still have been able to identify the Indian dead by their individualized accouterments for such details were as much a part of handed-down and often-retold stories as the actual events themselves.

# 4

When you came attacking,
why did not you have more men?
Why didn't you bring more men
so that you would be a little stronger?

*Sioux kill-talk song heard after the battle of the Little Bighorn*[1]

The Army's official report on the battle was based upon the mute testimony of the field where Custer and his men died. The report read,

The only real evidence of how [Custer and his men] came to meet their fate was the testimony of the field where it overtook them.... Custer's trail, from the point where Reno crossed the stream, passed along and in rear of the crest of the bluffs on the right bank for nearly or quite three miles. Then it came down to the bank of the river, but at once diverged from it again, as though Custer had unsuccessfully attempted to cross; then, turning upon itself, and almost completing a circle, the trail ceased. It was marked by the remains of officers and men, and the bodies of horses, some of them dotted along the path, others heaped in ravines and upon knolls, where halts appeared to have been made. There was abundant evidence that a gallant resistance had been offered by Custer's troops, but they were beset on all sides by overpowering numbers.[2]

In the over 125 years since the battle of the Little Bighorn, hundreds of authors have advanced theories to flesh out Sheridan's skeletal report on the affair.

---

[1]DeMallie, ed., *The Sixth Grandfather*, p. 197.
[2]Gen. Philip Sheridan's official report, in Finerty, *War-path and Bivouac*, p. 334.

Some of these researchers based their materials on information gleaned from the Reno and Benteen survivors; others depended upon native accounts in combination with white survivor testimony; a very few relied exclusively upon Indian participant accounts; others, using neither of these types of sources, came up with some very interesting studies which should be and have been shelved with the fiction.

This study was not intended to advance new theories about what happened to Custer, or why, but rather to reintroduce resources that could provide the basis for new theories, or support for old ones.

In the battle of the Little Bighorn, as in others, the Indians fought as individuals, following a culturally defined set of tactics involving stealth, surprise, ferocity, cruelty, personal daring, and a quick get-away. Quarter was neither expected nor given. Compare this type of fighting with that of the "civilized" white army of the day whose parade ground-drilled soldiers frequently complained of an Indian foe who refused to "just stand still and fight like white men." It was precisely this unpredictability, this refusing to play by classic military rules, which intimidated, demoralized, and panicked the soldiers, particularly those with little experience in Indian fighting. And 70 per cent of the Seventh Cavalry's overall strength in June of 1876 was made up of recruits.[3]

The ordinary soldier of the day was very poorly and hastily trained, so much so that one author has referred to these soldiers as the "collectively inexperienced."[4] There can be little doubt that many of the

---

[3]Fox, *Archaeology, History and Custer's Last Battle,* p. 266.
[4]Ibid., pp. 260, 270.

men in the lower ranks did not, could not, function as effective members of a military unit. The soldiers received little formal shooting practice so they were not as familiar with their carbines and sidearms as they should have been; this lack of experience and confidence cost them dearly.[5] But the proximity and numbers of the Indians so amplified the drawbacks of the issue single-shot carbine that even experienced soldiers could not reload fast enough to hold massed Indians at bay.[6]

The nature of Indian fighting was at best poorly understood by the U. S. military in 1876; the idea of adopting guerrilla tactics to defeat guerrilla fighters was still almost a hundred years in the future. Officers of Custer's day may have received an excellent grounding in classic military tactics, strategy, and history, but the common line soldier, if he could read at all, got his Indian-fighting knowledge from lurid dime novels. One of the reasons that Custer was sought after for this expedition was his reputation as an Indian fighter. In those days, anyone who hadn't been killed the first time out against Indians could boast a certain amount of uniqueness. At any rate, experience was by far the best teacher in the school of Indian fighting, but there was just not enough of that kind of experience to go around. Inadequate training and experience must be counted among the factors which contributed to the defeat of Custer's column.

According to John S. Gray, the main factor in Custer's defeat was inadequate knowledge of the terrain, as well as the enemy's numbers, whereabouts,

---

[5]Ibid., p. 264.
[6]Stands in Timber and Liberty, ed., *Cheyenne Memories*, p. 201.

movements, and mood. It was the information that Custer didn't have that killed him.[7]

Once in the vicinity of the Little Bighorn, Custer could rely on the Crow scouts' familiarity with gross features of the terrain. But a more detailed familiarity with the lesser features of his battle landscape eluded Custer. In the planning stages of the expedition, no one had had any idea of the tremendous distances involved, or how difficult the terrain would be, or where the Indians would be, or if they would be all together, or if all the separate commands would be able to support each other once everyone had assembled. It was not a good way to start a war.

When Custer visited Washington during his unpaid leave, he found that the Indian Office estimated that there were approximately 850 warriors missing from the agencies. Custer personally guessed that the number might be as high as one thousand. What Custer did not know was that the threat of an increasingly heavy military buildup on the reservations would soon force very large numbers of Indians away from the agencies and into the swelling camps of the off-reservation Indians, where lay safety in numbers.[8] Nor could Custer know that the Indian agents responsible would be so slow to inform the Army of the exodus.[9]

We have already seen that Lt. Bradley and his Crow scouts, a contingent of Col. Gibbon's command, had located the camps, and that this information, for some reason, was never passed on to either Terry or Custer. Reno need never have been sent off on his scout, only

---

[7]Gray, *Centennial Campaign,* pp. 183, 383.
[8]Ibid., pp. 208, 349.
[9]Ibid., p. 336.

to be heavily criticized later, unfairly, for blundering about the countryside scaring the Indians away.

If the Indians had not been aware that the Army had taken the field against them, they were certainly alerted to that fact by their encounter with Crook's forces a week before Custer arrived at the Little Bighorn. The Indians knew that the Army was literally out to get them. That they were not made particularly anxious by that fact was certainly revealing. Their very way of life was on the line; they would fight to the death to protect their families, and they did not lack confidence in their individual or collective abilities.

That the warriors who fought at the Little Bighorn on June 25, 1876, were confident of victory is obvious. A week earlier, Sitting Bull had foreseen that the Sioux and Cheyenne would win a great victory against the soldiers. And how could a people with so many strong spirit-helpers possibly lose? Dragonflies, owls, hail and lightning, and other designs were painted on bodies, clothing, shields, and horses as an appeal to the supernatural beings believed to have the power to tip the scales in a warrior's favor. These motifs, and the stuffed birds and medicine charms worn by some men, were believed to endow the owner with magical abilities. This support made for confident and dangerous fighters.

The short and simple analysis is that Custer was defeated because he went up against too many with too few. His decisions to break his command into ever-smaller units was a fatal one for over 260 men.

According to Scott and Fox, the recovery of artifacts through archaeological procedures provided new data

for the study of the battle of the Little Bighorn. These data, say these two, must be interpreted in concert with the historical record,[10] for the archaeological record complements the commentary of the Indian participants, and vice versa.[11]

Scott and Fox's findings consistently reaffirm the action as reported by Indian survivors over a hundred years ago. The division of Custer's forces, again, after he left Reno; the approach to the river by Custer or someone else from his command; the private battles of Lt. Harrington and Sgt. Butler; the order in which the companies died; the last surviving group—none of these events could have been corroborated by white, contemporaneous testimony.

The location and positioning of the artifacts give further proof of many other battle scenarios. For example, recovered cartridges fired from a particular weapon in the Calhoun position and in the Keogh position (along the ridge where the monument now stands) show that some of the Calhoun men went to join Keogh's group after (and *because*) Calhoun's position disintegrated.[12]

By careful comparison of the archaeological record with the Indian testimony and the drawings of the Custer battle, it may be possible to determine the relationship between these drawings and specific, archaeologically determined scenarios. At present, the identities of the soldiers in almost all of the drawings, and the movements of those specific soldiers over the Custer battlefield, has not been determined.

---

[10]Scott and Fox, *Archaeological Insights into the Custer Battle*, p. 6.

[11]Greene, *Evidence and the Custer Enigma*, pp. 49-51.

[12]Scott and Fox, *Archaeological Insights into the Custer Battle*, p. 117.

The Indian drawings of the Reno battle depict events which can be corroborated by the testimony of the Indians and white men who survived the fight. The drawings of the Custer battle depict events which can be corroborated by Indian testimony as well as by a smattering of white testimony based on battlefield observations of the dead by the living, and physical evidence uncovered in the archaeological survey conducted on site.

The drawings depicting Reno's attack on the southern end of the village show the numbers of warriors confronting him, and the steadily growing panic of the soldiers. The drawings support Reno's assertion that "the very earth seemed to grow Indians"[13] who moved up the valley to block his approach. The difference between the Reno and Custer battles is defined in terms of white survivors: many soldiers survived the Reno battles. These men later testified about Reno's attack, withdrawal, retreat, and river crossing. A comparison of that testimony with the pictographic drawings of the Reno conflict shows that the white testimony corresponds exactly with Indian testimony and the drawings as well as the interpretations of the drawings in this study. This correlation is the gauge by which the reliability of the drawings ought to be and can be measured. The fact that there were no white survivors to corroborate Indian testimony on the Custer battle should in no way detract from the reliability and validity of the drawings related to that battle.

The drawings presented in this study provide details previously lacking or under-emphasized in accounts of the Little Bighorn battle. Some examples are:

---

[13]Quote in Graham, *Abstract*, p. 278.

(1) the steadily increasing panic and demoralization of Reno's men in the face of growing numbers of Indians entering the battle;

(2) the ineffectiveness of soldiers who fired without aiming, or who never fired at all;

(3) the women and children who died in the Hunkpapa camp;

(4) the water carriers at the river and their battle with the Cheyenne on the opposite bank;

(5) The Indians' sighting of Custer and his five companies after he left Reno;

(6) Yellow Nose's capture of the guidon, and his other exploits;

(7) the suicide of Lt. Harrington; and

(8) the last soldiers who fled downhill to the ravine occupied by White Bull.

Plains pictographic drawings of the last century provide as no other medium can, a glimpse of life—an insider's point of view since the art was made about them, by them, and for them—of a culture so very different from any other. These are artistic renderings of actual events in the aggregate history of the people of the American plains.

In the early years of this century, Plains Indian artifacts of any kind could be obtained for only a few dollars. Today, old Plains Indian items command very high prices, especially ledger drawings and so forth. I have seen many drawings which have been unbound from ledgers so they could be sold individually to make sale easier and profits higher. As recently as December 11, 2002, on Canyon Road in Santa Fe, New

Mexico, I overheard a conversation in which the owner of a gallery well-known for its fine Plains Indian materials lamented to a prospective customer his inability to break up a consigned collection of six Cheyenne drawings to facilitate their sale. The price of the six together, he said, would be difficult to get. These drawings, originally sequences of historical events, have been reduced to mere isolated and disconnected vignettes. The loss of the integrity of such works is inestimable. Unfortunately, when museums and archives have the (rare) chance of acquiring pictographic art such as ledger drawings or smaller drawings on paper, the prices of the individual pieces are so prohibitive that the institutions can afford to buy only if they *have* been broken up for sale; the desire to save these pieces for posterity actually encourages their separation and scattering.

Pictographic drawings are now found in private collections, museums, historical societies, libraries, galleries, and archives. Many such pieces are part of larger accumulations of Plains artifacts. Unfortunately, the catalog or accession information with such pieces is often poor or altogether lacking. What is even sadder is the poor treatment some of these pieces receive. All of these drawing were made upon materials which now require special handling to prevent, or at least slow, deterioration. I have seen drawings stored unprotected in wooden drawers; nailed to plywood; displayed in wooden frames under harsh lighting; and rolled on cardboard tubes scrounged from garbage bins behind carpet stores. Perhaps one advantage of today's high prices is that purchasers will take better care of such expensive investments.

There are almost certainly hundreds of Plains pictographic drawings on paper, canvas, muslin, and hides scattered around the country. Capt. Pratt[14] told of commissioning many, many notebooks full of drawings from Cheyenne prisoners at Fort Marion, Florida; and at one time at a trading post near the Pine Ridge agency in South Dakota, "the story of the Custer fight was depicted in pictographs around the walls," along with a large painting by a Sioux youth who painted a mural at the direction of some warriors who had participated in the battle of the Little Bighorn.[15] Where are these works now?

Plains Indian pictographic drawings relating to the battle of the Little Bighorn are primary source materials. The interpretation of these pieces and their comparison with other sources is a process that is bound to shed light upon an event which, despite the number of books devoted to it, remains tantalizingly out of focus. The location, identification, description, and publication of more drawings on this subject and others could greatly expand our ethnohistorical knowledge base.

The drawings in this study unquestionably add to the body of knowledge concerning the battle of the Little Bighorn. They illustrate actual battle scenarios about which we previously knew little or nothing. All the drawings taken together give us a documentary view of an event for which imagination has been the sole illustrator. Written commentary from soldier-survivors of the battle has provided a valuable but one-sided perspective. These drawings have shown us what the battle looked like to the Native Americans who

[14]Hoebel and Petersen, *A Cheyenne Sketchbook, by Cohoe*, pp. 7, 9, 10.
[15]DeMallie, ed., *The Sixth Grandfather*, p. 64.

experienced it, and who then drew pictures of it as a way of preserving their history. It must have been an effective method—125 years later, we're still looking at these pictures and learning from them.

# Bibliography & Index

# Bibliography

Barry, David. *Indian Notes on "The Custer Battle."* Baltimore: n.p., 1937.

Blish, Helen. *A Pictographic History of the Oglala Sioux.* Lincoln: Univ. of Nebr. Press, 1967.

Brininstool, E. A. *A Trooper with Custer, and Other Historic Incidents of the Battle of the Little Big Horn.* Columbus: Hunter-Trader-Trapper, 1925.

Byrnes, James B. *The Artist as Collector: Selections From Four California Collections of the Arts of Africa, Oceania, the Amerindians and the Santeros of New Mexico.* Newport Harbor: Newport Harbor Art Museum, 1975.

Connell, Evan S. *Son of the Morning Star.* San Francisco: North Point Press, 1984.

DeBarthe, Joe and Edgar I Steward, ed., *Life and Adventures of Frank Grouard.* Norman: Univ. of Okla. Press, 1958.

DeMallie, Raymond J., ed. *The Sixth Grandfather: Black Elk's Teachings Given to John G. Neihardt.* Lincoln: Univ. of Nebr. Press, 1984.

Dippie, Brian W. *Custer's Last Stand: The Anatomy of an American Myth.* Missoula: Univ. of Montana Pubns. in History, 1976.

Dixon, Joseph K. *The Vanishing Race: The Last Great Indian Council.* Rodman Wanamaker, 1913; New York: Bonanza Books, 1975.

Dodge, Richard Irving. *The Plains of the Great West.* New York: Archer House, 1959.

DuMont, John S. *Custer Battle Guns.* Fort Collins: Old Army Press, 1977.

Ege, Robert J. *Settling the Dust: The Custer Battle, June 25, 1876.* Greeley: Werner Pubns., n.d.

Finerty, John F. *War-path and Bivouac, or the Conquest of the Sioux.* Norman: Univ. of Okla. Press, 1962.

Fox, Richard Allan, Jr. *Archaeology, History, and Custer's Last Battle.* Norman: Univ. of Okla. Press, 1993.

**175**

Godfrey, E. S. "Custer's Last Battle, by One of His Troop Commanders." *Century Magazine* (Nov. 1891 to April 1892), pp. 358-84.

Graham, William A. *The Custer Myth, A Source Book of Custeriana.* New York: Bonanza Books, 1953.

_____. *Abstract of the Official Record of Proceedings of the Reno Court of Inquiry Convened at Chicago, Illinois, 13 January 1879, by the President of the United States upon the Request of Major Marcus A. Reno, 7th Cavalry, to Investigate His Conduct at the Battle of the Little Big Horn 25-26 June, 1876.* Harrisburg: Stackpole Co., 1954.

Gray, John S. *The Sioux War of 1876.* Ft. Collins: Old Army Press, 1976.

_____. *Custer's Last Campaign: Mitch Boyer and the Little Bighorn Reconstructed.* Lincoln: Univ. of Nebr. Press, 1991.

Greene, Jerome. *Evidence and the Custer Enigma: A Reconstruction of Indian Military History.* n.p.: 1979.

Grinnell, George Bird. *Fighting Cheyennes.* New York: Charles Scribners' Sons, 1915; Norman: Univ. of Okla. Press, 1977.

Gruell, George E. *Fire and Vegetative Trends in the Northern Rockies.* Ogden: Intermountain Forest & Range Experimental Station, U.S. Dept. of Agriculture, 1983.

Hammer, Kenneth, ed. *Custer in '76: Walter Camp's Notes on the Custer Fight.* Provo: Brigham Young Univ. Press, 1976.

*Hardin Tribune.* 22 June 1923.

Hardorff, Richard G., ed. *Lakota Recollections of the Custer Fight: New Sources of Indian Military History.* Spokane: Arthur H. Clark Co., 1991.

Hoebel, E. Adamson and Karen Daniels Petersen. *A Cheyenne Sketchbook, by Cohoe.* Norman: Univ. of Okla. Press, 1964.

Hofling, Charles K. *Custer and the Little Big Horn: A Psychobiographical Inquiry.* Detroit: Wayne State Univ. Press, 1981.

Howard, James H., ed. *The Warrior Who Killed Custer: The Personal Narrative of Chief Joseph White Bull.* Lincoln: Univ. of Nebr. Press, 1968.

Hunt, Frazier. *Custer, the Last of the Cavaliers.* New York: Cosmopolitan Book Corp., 1928.

Johnson, W. Fletcher. *The Red Record of the Sioux: Life of Sitting Bull and History of the Indian War of 1890–'91.* n.p.: Edgewood Publishing Co., 1891.

Jordan, Robert P. "Ghosts on the Little Bighorn." *National Geographic* (Dec. 1986), pp. 786-813.

King, Charles. "Custer's Last Battle." *Harper's New Monthly Magazine LXXXI* (June-Nov. 1890), pp. 378-87.

_____. *Campaigning with Crook.* Norman: Univ. of Okla. Press, 1964.

Kuhlman, Charles. *Legend into History, the Custer Mystery: An Analytical Study of the Battle of the Little Big Horn.* Harrisburg: Stackpole Co., 1952.

*Leavenworth Weekly Times,* "The Stories of Low Dog, Crow King, Hump, Iron Thunder," 18 Aug. 1881.

Libby, O.G., ed. *The Arikara Narrative of the Campaign Against the Hostile Dakota, June, 1876.* New York: Sol Lewis, 1973.

Magnussen, Daniel O., ed. *Peter Thompson's Narrative of the Little Big Horn Campaign, 1876: A Critical Analysis of an Eyewitness Account of the Custer Debacle.* Glendale: Arthur H. Clark Co., 1974.

Mallery, Garrick. "Picture-Writing of the American Indians." in *Tenth Annual Report of the Bureau of American Ethnology, 1888–89* (Washington, D.C., 1893).

Mangum, Neil, ed. "Battle of the Little Big Horn, as Related by Charles Windolph, Company H, Seventh Cavalry, U.S.A." *Greasy Grass* (May 1985), pp. 2-6.

Marquis, Thomas. *Wooden Leg, A Warrior Who Fought Custer.* Lincoln: Univ. of Nebr. Press, 1931.

_____. *Custer of the Little Bighorn, Thomas B. Marquis, Eye Witness and Carefully Researched Accounts of Custer's Famous "Last Stand Battle" with the Cheyenne and Sioux Indians on June 25, 1876.* Lodi: Dr. Marquis Custer Pubns., 1967.

_____. *Keep the Last Bullet for Yourself: The True Story of Custer's Last Stand.* New York: Two Continents Pub. Group, 1976.

Maurer, Evan M. *Visions of the People, A Pictorial History of Plains Indian Life.* Seattle: Univ. of Wash. Press, 1992.

McCreight, M. I. *Chief Flying Hawk's Tale; A True Story of Custer's Last Fight, as Told by Chief Flying Hawk.* New York: n.p., 1936.

_____. *Firewater and Forked Tongues: A Sioux Chief Interprets U.S. History.* Pasadena: n.p., 1947.

McGaw, Jessie Brewer. *Chief Red Horse Tells About Custer: The Battle of the Little Bighorn, an Eyewitness Account Told in Indian Sign Language.* New York: Elseview/Nelson Books, 1981.

McLaughlin, James. *My Friend the Indian.* Boston: Houghton Mifflin Co., 1910.

Miller, David Humphreys. *Custer's Fall: The Indians' Story of the Little Big Horn.* New York: Duell Sloan and Pearce, 1957.

———. "Echoes of the Little Bighorn." *American Heritage* (June 1971), pp. 28-39.

Monaghan, Jay. *Custer: The Life of General George Armstrong Custer.* Boston: Little Brown and Co., 1959.

Morris, William E. and Neil Mangum, ed. "Reno's Battalion in the Battle of the Little Big Horn." *Greasy Grass* (May 1986), pp. 3-8.

Neihardt, John G. *Black Elk Speaks, Being the Life Story of a Holy Man of the Oglala Sioux.* Lincoln: Univ. of Nebr. Press, 1971.

*New York Herald.* 6 October 1876; 16 November 1877; 8 July 1876.

O'Brien, Lynne W. *Plains Indians Autobiographies.* Boise: Boise State College Western Writers Series, No. 10, 1973.

Petersen, Karen Daniels. *Plains Indian Art from Ft. Marion.* Norman: Univ. of Okla. Press, 1971.

Pohanka, Brian C. "Their Shots Quit Coming." *Greasy Grass* (May 1985), pp. 7-14.

Powell, Father Peter J. *Sweet Medicine: The Continuing Role of the Sacred Arrows, the Sun Dance and the Sacred Buffalo Hat in Northern Cheyenne History.* Norman: Univ. of Okla. Press, 1969.

———. *People of the Sacred Mountain: A History of the Northern Cheyenne Chiefs and Warrior Societies, 1830–1879, with an Epilogue 1969–1974.* San Francisco: Harper and Row, 1981.

Robotham, Rosemarie. "Is This the Bullet that Killed Custer?" *Life* (March 1985), pp. 115-17, 129-32.

Russell, Don. *Custer's Last.* Ft. Worth: Amon Carter Museum of Western Art, 1968.

Sandoz, Mari. *Crazy Horse, The Strange Man of the Oglalas.* Lincoln: Univ. of Nebraska Press, 1961.

———. *The Battle of the Little Bighorn.* Philadelphia: J.B. Lippincott Co., 1966.

Scott, Douglas D. and Richard A. Fox. *Archaeological Insights into the Custer Battle: An Assessment of the 1984 Field Season.* Norman: Univ. of Okla. Press, 1987.

Standing Bear, Luther and E. A. Brininstool, ed. *My People the Sioux.* Boston: Houghton Mifflin Co., 1928.

Stands in Timber, John and Margot Liberty, ed. "Last Ghastly moments at the Little Bighorn." *American Heritage* (April 1966), pp. 15-21, 72.

_____. *Cheyenne Memories.* Lincoln: Univ. of Nebr. Press, 1985.

Stewart, Edgar I. *Custer's Luck.* Norman: Univ. of Okla. Press, 1985.

Tillett, Leslie. *Wind on the Buffalo Grass: The Indians' Own account of the Battle of the Little Big Horn River, and the Death of Their Life on the Plains.* New York: Thomas Y. Crowell Co., 1976.

Utley, Robert M. *Custer Battlefield National Monument.* Washington: National Park Service, Dept. of the Interior, 1969.

_____. "Custer Legend." *American History Illustrated* (June 1976), pp. 4-9, 42-49.

_____. *Custer and the Great Controversy: Origin and Development of a Legend.* Pasadena: Westernlore Press, 1980.

Vestal, Stanley [Walter Stanley Campbell]. *Sitting Bull, Champion of the Sioux.* Norman: Univ. of Okla. Press, 1932.

_____. *Warpath: The True Story of the Fighting Sioux Told in a Biography of Chief White Bull.* Boston: n.p., 1934.

_____. "The Man Who Killed Custer." *American Heritage* (Feb. 1957), pp. 4-9, 90-91.

Walker, Judson E. *Campaigns of General Custer in the North-west and the Final Surrender of Sitting Bull.* New York: Promontory Press, 1966.

Welch, James. *Killing Custer: The Battle of the Little Bighorn and the Fate of the Plains Indians.* New York: W. W. Norton, 1994.

Wheeler, Keith. *The Scouts.* Old West Series, Vol. 24. New York: Time-Life Books, 1978.

Wills, Charles. *The Battle of the Little Bighorn.* Englewood Cliffs, 1990.

# INDEX

*For All to See:*
*The Little Bighorn Battle in Plains Indian Art*
has been published in an edition of
five hundred copies, each copy signed
by the author and numbered.
The book has been designed and produced
under the direction of Robert A. Clark,
and printed on 80 pound Starwhite Vicksburg,
Tiara, by Thomson-Shore, Inc., of
Dexter, Michigan.

This is copy number

_____374_____

*Sandra L. Brizée-Bower*